# TWO THOUSAND THOUGHTS

# TWO THOUSAND THOUGHTS

*By Arvind Sharma*

ANTHEM PRESS

FIRST HILL BOOKS
An imprint of Wimbledon Publishing Company Limited (WPC)

This edition first published in UK and USA 2023
by FIRST HILL BOOKS
75–76 Blackfriars Road, London SE1 8HA, UK
or PO Box 9779, London SW19 7ZG, UK
and
244 Madison Ave #116, New York, NY 10016, USA

*British Library Cataloguing-in-Publication Data*
A catalogue record for this book is available from the British Library.

*Library of Congress Control Number: 2022943647*
A catalog record for this book has been requested.

ISBN-13: 978-1-83998-727-4 (Hbk)
ISBN-10: 1-83998-727-8 (Hbk)

Cover image: Cover photograph by Faye Sutherland

This title is also available as an e-book.

# CONTENTS

# PREFACE TO TWO
# THOUSAND THOUGHTS

The culture of India has a tradition of what are called *subhāṣitas*. The word is hard to render in English exactly; it literally means "well said." Perhaps "well-turned sayings" would not be a bad translation. A *subhāṣita* comes close to what we refer to as a "quotable quote" in colloquial English, except that it is almost always in verse form. One can also hear in it the echoes of the *shera* of Urdu poetry and the Haiku of Japanese literature.

This inheritance embraced English when I encountered it at school, all the way from the ditties of early schooling to the verses of Alexander Pope.

My fascination with this form of literary expression carried into adult life, when I became an academic—a fascination with reducing one's experiences to sound bites, although hopefully without the touch of superficiality, and even triviality, associated with that term. Quotations can retain the catchiness of a sound bite, without losing their gravity.

These *subhāṣitas*, or "quotations," can profoundly affect one's perception of life and, sometimes, even precipitate life-changing experiences. Consider, for instance, the moment in the life of Martin Luther (1483–1546), when he felt that no matter how hard he tried, he could not be a perfect monk. It was a quotation which changed his life, a quotation from the Bible: "The righteous shall live by faith" (Romans 1:17). One has, of course, to be in Luther's state of mind to experience its full impact, but perhaps we can feel some of it in our imagination.

Let me share a few such quotations whose impact I was destined to feel throughout my life:

*Purity of heart means wanting one thing only.*
*In a free society, a few are guilty but everyone is responsible.*
*The ink of the scholar is more sacred than the blood of the martyr.*
*God is between two thoughts.*

Perhaps the impact of the thoughts expressed in the pages that follow will not be as sensational. I do hope, however, that the thoughts contained here will arouse your interest, or at least tickle your fancy.

# THOUGHTS

1. We can become attached not only to our affections but also to our afflictions.

2. Ignorance is bliss, but knowledge is ecstasy.

3. Soon our problem will be how to make sinning exciting.

4. If you know what you want from life it will give it to you.

5. Some mysteries are greater than the person trying to solve them.

6. The fisherman's net can catch everything except water.

7. Science saves us from pain; religion saves us from suffering.

8. Biography is gossip at its best.

9. Never allow pain to turn into grief.

10. Our illnesses enlarge our vocabularies.

11. In order to learn something, you have to get over the illusion that you already know it.

12. The quest of finding who we are makes us who we are.

13. How can you risk what you value if you value what you risk?

14. To be born is to land suddenly in the middle of a novel.

15. Love is not blind, but it is short-sighted.

16. The sun may shine on the saint and the sinner alike, but lightning is said to strike the sinner.

17. A writer's life is one long quest for the right word.

18. The setback will only set you back if you sit back.

19. Subtlety, without sincerity, is chicanery.

20. There is no magic bullet. You have to keep on firing till you hit the target.

21. With great human beings, their biography is history; with ordinary human beings, history is biography.

22. Human beings are not as different from each other as their circumstances make them out to be.

23. One's conscience does not believe in relative truth.

24. Bulldozers maybe a better bet for moving mountains than faith.

25. The moment a wave calms down, it disappears. So does the mind.

26. Truth is supposed to reflect reality, but a lie can change it.

27. There is no right time to be born, or to die.

28. Before you correct somebody, you had better be correct.

29. Both success and failure are exaggerations.

30. Death is a life-changing experience.

31. It is all right to go with the flow, but where is the flow going?

32. You can't keep a good man down, and you can't keep a down man good.

33. It is possible to get away with murder if you commit it on a sufficiently large scale.

34. God is not a lawyer sworn to defend you; God is a judge sworn to justice.

35. Life is one long battle against insecurity.

36. Only those who are prepared to make a fool of themselves ultimately find wisdom.

37. The fundamental feature of life, as of science, is not certainty but surprise.

38. I immediately feel a surge of affection for someone who can advance my self-interest.

39. The world penalizes us for what we say, not what we think.

40. Who knows—death may be the known unknown which leads us to the unknown unknown.

41. The word "ass" has two *ss* in it. The word "asinine" has only one. Now isn't that asinine?

42. We are not here to worry about life or death. We are here to make the most of what comes in-between.

43. You are spreading light even when you are carrying someone else's torch.

44. Selfish individuals may prevail against altruistic individuals, but altruistic societies prevail over selfish societies.

45. Don't be an abridged version of yourself.

46. I only wish to live until I die.

47. The greatest punishment for the liar is that he or she cannot trust others.

48. Have you ever wondered about the terrifying rightness of things?

49. Patients often outlive their doctors.

50. The true test of love is its ability to withstand disillusionment.

51. What we think are limits could be frontiers.

52. It is more romantic to challenge power than to exercise it.

53. Nothing fails like failure.

54. A thought should not be so deep that it is beyond reach.

55. The trouble with taking the high moral road is that it sometimes leads to a cliff.

56. The easiest way to win is by changing the rules of the game.

57. I am not a star. I am just an asterisk.

58. It is easy to be original. It is more difficult to be authentic.

59. As much has been achieved by skepticism as by faith.

60. Love is a form of gullibility.

61. Simplify until you can't.

62. Our undoing is usually our doing.

63. The moment you commit an error, you become more human but less credible.

64. Everyone asks me for the secret of my failure, but I don't let on.

———◦———

65. Nothing is more powerful than a lie attached to a truth.

———◦———

66. It is amazing how often we confuse the present with eternity.

———◦———

67. Is atrocious knowledge preferable to abysmal ignorance?

———◦———

68. It takes a lifetime to learn to enjoy the moment.

———◦———

69. Readiness to die for an opinion is no proof of its truth.

———◦———

70. As you and I know, perfection is overrated.

———◦———

71. Without the devil, creation would not have been news.

———◦———

72. What is closest to a person are not his thoughts but his dreams.

———◦———

73. The best way to enter someone's house is through a newspaper.

———◦———

74. The sun dispels darkness, but does it know it?

———◦———

75. A leader is one who can make ordinary people do extraordinary things.

———◦———

76. The problem with religions is that they start playing God.

77. Nothing that happens is trivial.

78. God guarantees outcomes, not successes or failures.

79. The problem with going with the flow is the undertow.

80. It is often more important to say what is appropriate than to say what is true.

81. Magnanimity in defeat is a rarer virtue than magnanimity in victory.

82. It is not so much that the pious suffer, as that those who suffer think themselves pious.

83. All jealousy is local.

84. What do women want? Women want the most precious thing in the world—attention.

85. We experience loss of our ego every night when we sleep—and isn't it nice?

86. Even in falsehood it is the power of truth which is at work. No one would believe a lie unless one thought it was true.

87. If one's stride is sufficiently wide and sufficiently strong, obstacles can become stepping stones.

88. Miracles are impressive but not dependable.

89. If you don't go up the steep learning curve, you will come sliding down it.

90. Marriage involves a massive invasion of privacy.

91. It is only when we have forced reason to its limits, that we recognize the limits of reason.

92. The range of our thoughts exceeds the range of our words, and the range of our experience exceeds the range of our thoughts.

93. People talk about the light at the end of the tunnel. But what about the tunnel at the end of the light?

94. Innocence may be defined as charismatic ignorance.

95. Longevity does not guarantee immortality.

96. Simple facts can have complex consequences.

97. Greatness cannot be prescribed. It can only be recommended.

98. To every rule you make, life will demand an exception.

99. Sometimes we know too much about a person but not enough.

100. The insight of one age is the platitude of another.

101. Onlookers often know which move would be better than the players—but they win no prizes.

102. Life is not black and white, not even gray—it is Technicolor.

103. We are as honest as the questions we ask of ourselves.

104. Love knows no hierarchy.

105. Democracy has a way of dismaying us with its electoral outcomes.

106. Practice can evolve options unknown to theory.

107. The scales of justice do not always seem to be in balance because they are often in motion.

108. Sometimes I get more than I deserve, and sometimes less than I deserve, so that ultimately, I get what I deserve.

109. Here is my favorite Zen koan: What was your account like before it was opened?

———⊰◆⊱———

110. Pain is physical; suffering is mental; evil is moral.

———⊰◆⊱———

111. Polyphony is not cacophony.

———⊰◆⊱———

112. Weightlessness is different from flying in the air.

———⊰◆⊱———

113. The task of the historian is to make what happened appear inevitable.

———⊰◆⊱———

114. More tragedies are caused by foolishness than viciousness.

———⊰◆⊱———

115. If you can't be a genius, at least be ingenious.

———⊰◆⊱———

116. There is no perfect part in a play, but each and every part of it can be played perfectly.

———⊰◆⊱———

117. There are no perfect persons, only perfect moments.

———⊰◆⊱———

118. It is hardly wise to think oneself so.

———⊰◆⊱———

119. Failures are also gifts, they are just not gift-wrapped.

———⊰◆⊱———

120. Life marches funeral by funeral.

121. Never be careless but always be carefree.

122. The one constant in all the relationships you have is you.

123. If you feel you are in heaven, keep going and you will reach hell; and if you are in hell, keep going and you will reach heaven.

124. Doing good makes us feel good; feeling good makes us do good.

125. What is limited is limiting.

126. All roads lead to God, but one should be prepared for accidents on the journey.

127. Nature abhors a vacuum. So does power.

128. Our sunset is sunrise somewhere else.

129. Life is a constant reality check.

130. People may forget what happened, but they remember what was happening to them when that happened.

131. It is true that, in the long run, we are all dead. But it is also true that in the long run, others take our place.

———◆———

132. Never make the mistake of identifying a country with its regime.

———◆———

133. Past and future are states of mind rather than conditions of time.

———◆———

134. Anger is the enemy of analysis.

———◆———

135. It is not that the blind do not see. It is rather the case that the blind see only darkness.

———◆———

136. One arrives at a *position*, but one *discovers* the truth.

———◆———

137. If the success was spectacular then the failure is also going to be sensational.

———◆———

138. Familiarity breeds abbreviations.

———◆———

139. Causation works. The question is: What causes causation to work?

———◆———

140. The distinction between apples and oranges vanishes when we treat both of them as fruits.

———◆———

141. Is life a melody or a symphony?

———◆———

142. Movements either go too far, or don't go far enough.

---

143. If hypocrisy is the homage vice pays to virtue, then temptation is the homage virtue pays to vice.

---

144. The police save us in the retail; armies kill us on the wholesale.

---

145. How to act in our own best interest is a challenge we never quite master in life.

---

146. The present is different from the thought of the present.

---

147. One can work tirelessly if one works effortlessly.

---

148. Something does not have to be perfect to be beautiful.

---

149. Vice may be nothing more than the unqualified affirmation of life.

---

150. It is devotion if you think of only one thing, but it is obsession if you think of one thing only.

---

151. A blunder can be worse than a crime.

---

152. What if God judges us more by the sincerity with which we hold our views than by their truth?

---

153. There are many ways of lying but only one way of telling the truth.

———◆———

154. Life used to be virtue, now it is virtual.

———◆———

155. Did your future change because you looked at it?

———◆———

156. That the impossible can be achieved through the absurd is the message of Zen.

———◆———

157. If the world is God's dream, then God is having a nightmare.

———◆———

158. Life is too short to accomplish anything, and eternity is too long.

———◆———

159. God is compassionate but not sentimental.

———◆———

160. Perseverance and obstinacy may be two sides of the same coin.

———◆———

161. The question has been asked: Is there anything more seductive than purity? And the answer is: charity.

———◆———

162. Do not confuse a happy marriage with a harmonious marriage.

———◆———

163. It is a remarkable fact that sometimes faith is not destroyed even after the certitude on which it was based has been shattered.

———◆———

164. What we find flattering indicates the level at which our consciousness is trapped.

165. Some know more than they remember, and some remember more than they know.

166. The secret of the spiritual life consists in extending the calm before the storm into a calm during it.

167. Sometimes we love our problems too much to solve them.

168. Prejudice is often used to support principle.

169. What is the point in reaching another milestone on the road to nowhere?

170. Improvement involves change, but every change is not an improvement.

171. Availability is the greatest aphrodisiac.

172. To be completely obedient one must be completely attentive.

173. Can one measure pleasure?

174. The wave, if it looks within, will find the ocean; the ocean, if it looks within, will find the wave.

175. There may be others in you, but there is no one other than you.

176. Never confuse austerity with poverty.

177. Communism performed the feat of being violent and utopian at the same time.

178. Children mistake Santa Claus for God; and grown-ups mistake God for Santa Claus.

179. The fact that you are going to let a thousand flowers bloom does not mean that you don't have to eliminate the weeds.

180. How many times has the sun gone round the earth? Not even once.

181. Intentions change when possibilities change.

182. There is all the difference in the world between a humbling experience and a humiliating experience.

183. The optimist thinks the glass is half full; the pessimist thinks the glass is half empty; the realist wonders whether there is enough water in the glass to quench one's thirst; and the scientist calculates how many ounces it comes to.

184. Some of the realities of today were not even the possibilities of yesterday.

185. Each one of us has to cross our own Rubicon.

186. A fearless person has no fear. A brave person overcomes fear.

187. People have been known to act unjustly in order to appear fair.

188. You cannot step in the same river twice, not only because it is not the same river, but also because you are not the same you.

189. Before practicing patience, make sure you are in the right queue.

190. Let us not forget, as we chase our own dreams, that it may be within our power to make someone else's dream come true.

191. The fruit falls close to the root.

192. Regret is the echo of the lost opportunity which was not heard clearly the first time.

193. Flowers are at their most fragrant when crushed.

194. The con-artist cheats others; the selfish person cheats oneself.

195. Anybody who has money to burn can set the world on fire.

———◆———

196. Every ideal ends up as an illusion but in the process leads humanity forward.

———◆———

197. Many an argument has been won by changing the subject.

———◆———

198. Some say that little knowledge is a dangerous thing, but should not one be wrong rather than ignorant?

———◆———

199. The real test of a leader is the kind of leader he or she leaves behind.

———◆———

200. One should not come out of the closet just to go into another.

———◆———

201. One needs to ask just one question of eternity: When is all this going to end?

———◆———

202. Every religion, like every human being, is entitled to be judged by its best moment.

———◆———

203. Beliefs are tested by logic; faith is tested by life.

———◆———

204. Tears are liquid poetry.

———◆———

205. Trees keep growing while standing completely still.

———◆———

206.  Beauty is truth made visible.

207.  Greed turns hope into expectation.

208.  One's life with one's wife should be one long compliment.

209.  Love is blind; flirtation closes its eyes.

210.  There are no anonymous tears.

211.  Innocence, like ignorance, offers no protection against the malice of the world.

212.  Goodness is less metaphysical than truth, and less aesthetic than beauty, but more human than both.

213.  When the teacher is ready, the student appears.

214.  The ultimate fruit of education is a readiness to learn.

215.  To be able to face oneself is the ultimate test of courage.

216.  Every passing moment is a meditation on death.

217. We tolerate our nightmares so that we can continue to dream.

———◆———

218. There is no horror without imagination. Hence all horror is imagined.

———◆———

219. Falsehood is more characteristic of life than truth. And that is the truth.

———◆———

220. Sometimes a whole lifetime is revealed in a word or a gesture.

———◆———

221. Realism, without sympathy for the subject, degenerates into cynicism.

———◆———

222. Memories are the laughter of time.

———◆———

223. We are both different from others as well as resemble others, and thus it comes about that every human being is a combination of individuality and humanity.

———◆———

224. Autobiography consists in making a monument out of the moments of our life.

———◆———

225. One idea seeds another.

———◆———

226. Every dogma has its day.

———◆———

227.  If problems were opportunities, then crises would be windfalls.

228.  Philandering is an overrated vice.

229.  We forgive wrongs but nurse insults. Pride is more potent than morality.

230.  Humor is the shock-absorber on the bumpy road of life.

231.  Some get what they want; others get experience. Everybody gets something.

232.  We also unlearn from experience.

233.  Stupidity is only a failed attempt at being intelligent.

234.  The hottest place in hell is reserved for the coldest heart.

235.  If you don't have art within you, you will not find it in the gallery.

236.  We admire a person for telling the truth when we realize that we would have lied in the same circumstances.

237.  Music dissolves time.

238. The things we know best are not the things we have been taught, but the things we have learned.

———◦———

239. A compass which points in all directions is not of much help.

———◦———

240. One who can kill for you can also kill you.

———◦———

241. Conscience is the ventriloquism of God.

———◦———

242. Can light be patented?

———◦———

243. One may hate inaccuracy more than lying because the former involves the pretense of truth.

———◦———

244. No child has an illegitimate mother.

———◦———

245. Elitism could be a defense mechanism against popular rejection.

———◦———

246. Divorces happen when people are more interested in the wedding than in the marriage.

———◦———

247. Start a habit.

———◦———

248. Tolerance is the language of the heart.

———◦———

249. We hold some ideas, and some ideas hold us.

250. A good listener hears and understands every word that was not uttered.

251. Women who complain that he is not the man they married forget that they married the man.

252. Winning seems to absolve one of sinning.

253. It does not matter who wears the pants in a marriage so long as both the partners keep theirs on.

254. A peer is one whose opinion about you can change your opinion about yourself.

255. Preparations beforehand avoid reparations afterwards.

256. Failure is merely a painful form of education.

257. It would be a better world if our own faults filled us with as much righteous indignation as those of others.

258. Marriage is the union of two dissenting adults.

259. Necessity may be the mother of invention, but opportunity is its father.

———◈———

260. All our problems could be due to ignorance—but who knows?

———◈———

261. Love will taste sour to those who think revenge is sweet.

———◈———

262. The problem with the handwriting on the wall is that it is often illegible.

———◈———

263. You cannot remain in the dark yourself if you show light to others.

———◈———

264. The virtuous are always contented with what they have but not with who they are; the rest are always contented with who they are and never with what they have.

———◈———

265. The faster the planes fly, the longer it takes to get to the airport.

———◈———

266. Love can be duplicated but it can never be replicated.

———◈———

267. A realized person is one who, when sent running up the tree by a lion, enjoys the scenery and the lion as part of it.

———◈———

268. Sometimes one is uncertain whether one received a pat on the back or a stab in the back.

———◈———

269. The gentleman does the nastiest thing in the nicest way, and the cad does the nicest thing in the nastiest way.

270. The right place to marry the man of your dreams is in the dream.

271. When you are in love you want to be with the person all the time, except when you are cheating on them.

272. Do not confuse restraint with repression.

273. Time feels all wounds.

274. Too many people are busy trying to study the elephant with a microscope and the mosquito with a telescope.

275. So long as people are willing to die for falsehoods, falsehoods will not die.

276. Neither a victimizer nor a victim be.

277. One may cease to be optimistic but one must never lose hope.

278. Character manifests itself in life as events.

279. Forgiveness is the past's contribution to the future in the present.

280. God reveals himself or herself to the seeker only when the seeker gets dangerously close.

---

281. All those whom we meet in life become part of us.

---

282. History repeats itself because it takes time for the message to sink in.

---

283. The hatchet has not been buried until an olive tree grows on that site.

---

284. No amount of dreaming about waking up in the dream, is going to wake you up from the dream.

---

285. Make me mortal with a kiss.

---

286. The cure for stupidity is not learning but wisdom.

---

287. Necessity is the mother of another kind of invention—lying.

---

288. A dogma is a truth with a reputation.

---

289. It is not always clear we have changed or things have.

---

290. It is no less logical that a saint might become a sinner than that a sinner might become a saint.

---

291. Cleverness makes us smirk, but folly makes us laugh.

292. Knowledge is distilled information; wisdom is distilled knowledge.

293. Our doubts may sometimes turn out to be absurd, but it would be absurd not to doubt.

294. Confusion between the true and the false contributes to error in knowledge; and confusion between the ideal and the real contributes to error in judgment.

295. If one digs oneself into a hole, then one should dig deep enough to strike oil.

296. There can be no progress in dealing with eternal verities, only participation.

297. We may think it passes, but time is the same at all times.

298. What longs for you belongs to you, and you belong to what you long for.

299. Life is a joke in search of a punch line.

300. If I have to go down, then it had better be on the Titanic.

301. There are no strangers, only people we haven't met.

302. It is one failure not to see the parts in the whole; and it is another failure not to see the whole in the parts.

303. Not only do I see the hand of God everywhere, I see his finger-prints all over the place.

304. Life offers no solutions, only a choice.

305. Most do not regret the fact that they did something wrong; they only regret the fact they got caught.

306. People want love but need sympathy.

307. The taller you are the longer the grave.

308. God rewards the efforts of even an atheist (such is the power of action).

309. We talk of justice when we can no longer talk of love.

310. Intelligence knows its limits, but stupidity is free from any such constraints.

311. Every dream runs the risk of becoming a nightmare.

312. When we avoid others, we are also running away from a part of ourselves.

313. God hides things by putting them too close to us.

314. We don't have desires; our desires have us.

315. Failure is not hard to understand but it is often difficult to accept.

316. Hate can bind two people as much as love.

317. Are we not, all of us, really impersonating ourselves?

318. You think cancer is bad? Ask the cells who are having the time of their life.

319. Suffering is not an affirmation of our worthlessness but of our worth.

320. If we are hasty, time works against us; if we are patient, time works for us.

321. Sisyphean labors only end in Pyrrhic victories.

322. Stop worrying. Start thinking.

323. What would the world be like if we could feel our thoughts and think our feelings?

324. Pain is necessary, but suffering is superfluous.

325. There are no holes in the whole.

326. Change your feelings and feel the change.

327. Look at the darkest spot of your heart and you will find that light is trying to escape from it.

328. Losing hope is the easy way out.

329. Romance is the advertisement of marriage.

330. Conversion means renouncing the errors of one religion for those of another.

331. If a caterpillar can become a butterfly, then anything can happen.

332. Information is the beginning of transformation.

333. If the past is not fully past, then it is not possible to be fully present in the present.

334. If you want to realize the hollowness of our desires, look at them from the perspective of one who doesn't have them.

335. It takes two to love, but only one to be loving.

336. A room has no temperature of its own. If you come into it from a colder place, it is warm; if you come into it from a warmer place, it is cold.

337. It is difficult to keep the hearts together and the bodies apart.

338. If you reflect on your life, your life will reflect it.

339. Being the oppressor can be as oppressive as being the oppressed.

340. If God is also self-righteous, then we are done for.

341. Don't leave any person worse off than you found him or her.

342. The past and the future is in our head, but the present is in our hands.

343. For horizontal movement, go with the wind; for vertical movement, go against the wind.

344. One should distinguish, should one not, between caution and hesitation.

345. Celibacy is not about sex. It is about single-mindedness.

346. The secret of life has been discovered. It is wanting one thing only.

347. Spiritual living consists in being spontaneous without being impulsive.

348. The question is not whether God exists but whether we exist for God or not.

349. Life either brutalizes you or sensitizes you.

350. The problem with being tough, for a sensitive person, is not so much whether the other person can take it, but whether one can take it oneself.

351. The universe itself is schizophrenic: look at quantum mechanics and relativity.

352. Before you try to be modest, make sure you have something to be modest about.

353. It is very difficult to construct a coherent philosophy of life around marriage.

354. To claim to be objective is pretentious; but to deny that one might try to be so is ridiculous.

355. So life is unfair. Have we ever thought where we might be if it were fair?

356. Failure can be liberating.

357. Where does one's headache go after it has been removed?

358. Your death is usually experienced more by those around you than you.

359. There are as many paths as there are travelers.

360. We must distinguish clearly between the failures of faith and the failures of the faithful.

361. Humiliation knows no age.

362. Act on your anger, but not in anger.

363. It is either coincidence or karma.

364. The bigger the drum, the greater the hollowness.

365. The greatest danger in buying someone off is that it may be you who is selling out.

366. Darkness is frustrated light; light is liberated darkness.

367. Spontaneity is one way of dealing with uncertainty, the other is planning.

368. People who love you have power over you, although people who have power over you may not always love you.

369. Can you stay afloat on the river of life if your heart is sinking?

370. The last is not the least; the last is the most because it completes the whole.

371. Marriage is the cure for bachelorhood. There is no cure for marriage.

372. Everyone's life is a scandal which has not hit the headlines.

373. When people say everyone is a fool, I think they have one exception in mind.

374. Heresy often saves one from apostasy.

375. The great challenge in life is to make experience yield ideas.

376. The power of politics lies in the fact that it can turn a problem into a crisis.

377. Unfortunately these days people cast their bread upon the waters in the hope of getting tuna sandwiches.

378. All lives represent varying degrees of tragedy.

379. What happens when one begins to doubt doubting?

380. Should wisdom limit knowledge?

381. It is human to err, but it is equally human that someone will draw your attention to it.

382. The secret of spiritual life consists in being enthusiastic without being exclusive.

383. The applause of thousands begins as the applause of one person.

384. The mind is not a vessel to be filled but a fire to be kindled.

385. Virtue consists not in being incapable of sin but in being incapable of deception.

386. Sudden intensity cannot be a substitute for patient regularity.

387. One swims in the same waters in which one can drown; and one can drown in the same waters in which one swims.

388. All choices involve sacrifice.

389. For a moral person, the fact that there may be no moral law governing the universe, may be all the more reason for acting morally.

390. Jealousy betrays a lack of imagination. If the other guy can do it, so can you.

391. With complexity comes complicity.

392. I would rather be in the hell I want to be in than the heaven I don't want to be in.

393. Yes, the devil may quote the scripture, but it is still scripture, and you can quote it too.

394. It is the beauty of love that perfect love is possible between two imperfect people.

395. The problem is not danger but fear.

396. Life is never a failure if you are celebrating a birthday.

397. What lies behind us, and what lies ahead of us, is nothing compared to what lies in front of us.

398. What we see depends on where we look.

399. Empires look invincible just before they crumble.

400. Marriage is an amazing phenomenon. Those who are in it are trying to get out and those who are out are trying to get in.

401. Does life possess meaning? Life may or may not possess meaning but the enigma does.

402. It seems that for most of my life, I have been out on my own recognizance.

403. All that separates the surgeon from the assassin is the motive.

404. A failure is a veiled invitation to try again.

405. The voice of the true prophet starts out by being a cry in the wilderness.

406.  Things happen to us because statistics need a face.

---

407.  What even your detractors concede is the real truth about you.

---

408.  Intellectual activity essentially consists in reducing confusion to ambiguity.

---

409.  Try not to be in love with the problem so much as not to solve it.

---

410.  Suffering is endowed with a hidden power to shape history.

---

411.  We don't just injure those whom we hate; we also come to hate those whom we injure.

---

412.  Would one not prefer tragic achievement to staid success?

---

413.  Conquerors are successful terrorists.

---

414.  Does moral integrity presuppose metaphysical clarity?

---

415.  People may not die for a scientific truth, but they will kill for it.

---

416.  If you want to live in a new part of the universe, just alter your orbit.

---

417. The secret of getting what you want is really wanting it.

⸺◆⸺

418. Life seems to assume that all of us are versatile geniuses.

⸺◆⸺

419. Better to rely on activity than serendipity.

⸺◆⸺

420. Love everything, otherwise what is the difference between love and partiality.

⸺◆⸺

421. Thought is at its best when tinged with positive emotion.

⸺◆⸺

422. The price of being a bridge is that you get trod upon.

⸺◆⸺

423. All jewels are stones, but all stones are not jewels.

⸺◆⸺

424. Part of the problem of calling someone less than a gentleman is that it makes you less of one for saying so.

⸺◆⸺

425. Everyone has something to say if we listen long enough.

⸺◆⸺

426. God sometimes approaches us as our enemy.

⸺◆⸺

427. Avoid hurry, mental as well as physical.

⸺◆⸺

428. Even the death of a person from the fear of an imaginary snake cannot prove that the snake is real.

———⊳•⊲———

429. It is the necessity of virtue which makes a virtue of necessity.

———⊳•⊲———

430. There is a world of difference between not having enough bread and bread not being enough.

———⊳•⊲———

431. Sometimes wisdom requires that we allow ourselves to be fooled.

———⊳•⊲———

432. In order to find out what is true, one has to begin by doing what is right.

———⊳•⊲———

433. There is all the difference in the world between being blind to the light, and being blinded with light.

———⊳•⊲———

434. If life can be so exciting, death must be mind-blowing!

———⊳•⊲———

435. Everyone claims to be doing good to everybody in the world. Then why is it such a mess?

———⊳•⊲———

436. In order to grasp something else, we have to let go of what we are holding on to first.

———⊳•⊲———

437. Is the universe seeking its essence through all of its manifestations?

———⊳•⊲———

438. More have been driven to despair by a husband or a wife than by life.

---

439. The same crisis in life makes some people generous and others petty.

---

440. One is allowed to feel sad, but not depressed.

---

441. Just as there are contemporary answers to perennial questions, there could be perennial answers to contemporary questions.

---

442. Is death always fatal?

---

443. Without duality there can be no intentionality.

---

444. There are more stars in heaven than the number of thoughts that pass through our minds on a single day.

---

445. As they say: There are old men and there are bold men, but there are no old bold men.

---

446. Don't let your desire to prefer peace to war tempt you into preferring injustice to justice.

---

447. Perhaps the mystery of life isn't so much meant to be solved as savored.

---

448. The great virtue is not consistency, but sincerity.

449. In life, sometimes the familiar becomes strange, and the strange familiar.

450. How many philosophers can resist the temptation to be profound?

451. We get what we deserve. And if we get more than we deserve, then we are only left with what we deserve.

452. What really differentiates people more than differences in ability is differences in the degree of ambition.

453. If you really wanted to be the other person, you would have been the other person.

454. Sacrifice your preferences for your goals.

455. Don't seek perfection; success will do.

456. There is a confusing moral symmetry between being a coward and being a pacifist.

457. Life is part fact, part fiction, and part fraud.

458. It has been said that you can escape everyone except yourself; but even that is possible in self-deception.

—————

459. If God gives you only what he thinks you can handle, then apparently God thinks I can handle anything.

—————

460. In order to win one must first join the fight.

—————

461. Sometimes one has to go through hell to reach heaven.

—————

462. Living too is one way of committing suicide.

—————

463. Don't put yourself down. Others are already doing a far better job of it.

—————

464. Every moment is once-in-a-lifetime moment.

—————

465. Intellectual integrity is a constant struggle against the seemingly similar but really opposite tendencies of rationality and rationalization.

—————

466. The obvious is the hardest to prove.

—————

467. People can have beautiful faces but terrible lives.

—————

468. That one should have no desires does not mean that one should have no goals.

---

469. It is either your tears or theirs.

---

470. Forbidden fruits produce the sweetest juice.

---

471. Anger, without power, is folly; folly, without power, is suicide.

---

472. Give up things before things give you up.

---

473. I am not sure any more if I want all my prayers to be answered.

---

474. Nobody ever beats you; you lose.

---

475. Seek truth, not certitude.

---

476. The distractions of virtue are even more seductive than those of vice.

---

477. I am a mediocre imitation of myself.

---

478. All of us are knowledgeable—but on different subjects.

---

479.  Who are we? We are the sum of our desires.

480.  We will think less negatively of ignorance if we realize that knowledge is born out of it.

481.  I don't know whether pride goes before a fall, but it certainly goes after it.

482.  Beware! Sometimes by acting like an angel, we may create monsters.

483.  The gap between what one has achieved and what one wants to achieve is called ambition.

484.  When more light is cast where there is already light, it often produces a shadow.

485.  We can hide death, but we cannot hide from it.

486.  One's own eagerness is a poor earnest of the other person's interest.

487.  Would you celebrate victory, or would you rather celebrate bravery?

488.  If the potential is there, it's there.

489. Avoid triumphalism if you want to triumph.

490. Birth is the opposite of death, not life.

491. The road to the center goes through the periphery.

492. Make sure you are being patient—and not just wasting your time.

493. No one will betray us as much as we betray ourselves.

494. The gossip which goes on at parties is nothing when compared to the gossip which goes on in our own mind.

495. The borders of our own inner universe are far more unbounded than those of the outer universe.

496. Is time the echo of eternity?

497. God is quite impartial. He also helps atheists.

498. Anger is a cousin of desire.

499. The problem is that miracles don't happen often enough to constitute a solution.

500. We do not always suffer for our sins. We also suffer for our weaknesses or misjudgments.

501. There are some tensions we should embrace rather than try to get rid of.

502. The present is always virgin.

503. Keep a fad going and it becomes a fashion.

504. The text usually outlives the context.

505. The only difference between mysticism and madness is that mysticism is not madness.

506. How did *one* become *first* is the grand metaphysical question.

507. Truth may be relative but duty is absolute.

508. I didn't expect anything, but I was still disappointed.

509. The academic's life is often a combination of high thinking and low living.

510. There is no ideal form of government. Whatever form of government we have, we will have to make it function in an ideal way.

511. The best person to have an affair with is your spouse.

512. Salary: month-to-month resuscitation.

513. Just as being liked is an index of popularity, being resented may be an index of power.

514. Peace sometimes conceals violence.

515. If your disposition is sunny, you create a new dawn wherever you go.

516. Why am I?

517. Are we going to sacrifice the present for the future, or the future for the present?

518. How do we know when the mind is projecting reality and when merely reflecting it?

519. Who is to say God is not trying out tough love on us?

520. What happens in the world is more often determined by will than virtue.

521. Turning the other cheek is also one way of facing the enemy.

522. Secularism converts sins into crimes.

523. Do we know because we reason, or do we reason because we know?

524. The intimations of the absolute are not absolute.

525. It is better to make a virtue of necessity than to make a vice of it.

526. Are we emotionally prepared to accept the consequences of being only rational?

527. Does the fact that I have two parents make me a split personality?

528. Karma forces rather than coerces, and impels rather than compels.

529. Everything happens in space, and yet nothing happens to space.

530. If we are not instruments, then we are victims.

531. In order to understand a truth, you must be able to stand it.

532. Such is the paradox of power: that those who do not desire it should get it, but only those who desire it get it.

533. The wave dips before it rises.

---

534. Nothing ever ends.

---

535. Let's look at the positive side of it. A loser has nothing to lose.

---

536. We have to distill life to find out whether it is wine or soda water.

---

537. The facts are often less than the truth.

---

538. Never confuse frustration with failure.

---

539. One advantage of being able to suffer fools is that one finds it easier to live with oneself.

---

540. Being nice makes good copy but bad history.

---

541. Darkness is the womb of light.

---

542. God connects the dots differently than us.

---

543. Those who would leap to spiritual perfection must first clear the high moral bar.

---

544. If you washed the dishes, what did the dishwasher do?

———◆———

545. Guilt is proof of sincerity.

———◆———

546. One moves in as many worlds as the languages one knows.

———◆———

547. Either give up your goal or go after it.

———◆———

548. We have made it into a moral sermon, but life could well be a business proposition.

———◆———

549. We often mistake the usual for the normal.

———◆———

550. The exhortation to love your neighbor as yourself will only work if you love yourself to begin with.

———◆———

551. The philosopher is often in the unenviable position of one who can provide an answer but not a solution.

———◆———

552. What good does it do if the heart is pure but the mind is clouded?

———◆———

553. I believe in the existence of my eye not because I see it, but because through it I see everything.

———◆———

554. We are always more eager to change the world than ourselves.

———◆———

555. It is not always necessary that all questions be answered for the problem to be solved.

———◦———

556. All of us have our emotional blackholes from which light is trying to escape.

———◦———

557. Each of us is capable of doing the thing we most detest.

———◦———

558. Time is the same all the time.

———◦———

559. Being enlightened means never having to say: Why me?

———◦———

560. You are not where your body is but where your mind is.

———◦———

561. Being between a rock and a hard place may not be all that bad. Their friction may start a fire.

———◦———

562. Many can understand the truth but few can withstand it.

———◦———

563. Achievement transcends successes and failures.

———◦———

564. The truth may unsettle the seeker after truth, but it never upsets him.

———◦———

565. Many a life may be summed up as a journey from Viagra to Valium.

———◦———

566. It is the waves that clash, not water.

567. Sometimes one only discovers one had a longing for certain things, only after they have been met.

568. The world is no doubt the poem of God but God often writes blank verse.

569. Success requires virtue, and sometimes lack of it.

570. What is a ripple in an ocean of consequencies?

571. Nothing is more educational than to be called upon to justify something in which we believe implicitly.

572. The unspoken is often heard.

573. God is never vicious, although often mischievous.

574. Would the serpent die if it bit its tail?

575. We always know more than we know how.

576. Our life is the sum of our exertions.

577. You can't cozy up to truth.

578. One should talk of God's will and power only after one has exhausted one's own will and power.

579. There is freedom in fluidity.

580. Arrogance is often used to camouflage ignorance.

581. Armor protects us, but it can also weigh us down.

582. We are the sum of our hopes and the subtraction of our fears.

583. Being clueless does not mean that you are practising Zen.

584. Life is a somewhat negative teacher: more prone to telling you what is wrong than what is right.

585. Life is too short to be psychoanalyzed.

586. Wars are often lost or won in times of peace.

587. Two halves of a globe are so empty by themselves but not together.

588. A blind man carries a lamp not that he might see others but that others might see him.

—————

589. Even God hates incompetence.

—————

590. Would one rather be wrong than ignorant, and ignorant rather than stupid.

—————

591. Ships are not built for ports; ports are built for ships.

—————

592. We have no desires when we are happy.

—————

593. It is always safer if it is you talking to God rather than God talking to you.

—————

594. Definition is death.

—————

595. Life is a constant struggle to avoid hypocrisy.

—————

596. True love does not tell everything, but it has no secrets.

—————

597. The ancient way may be ahead of the modern in wisdom, if the modern is ahead of it in technique.

—————

598. I need social skills to get on with myself.

—————

599. Make sure that what you want is consistent with what you want to be.

———◆———

600. We feel prepared to accept authority to the extent we are prepared to abdicate responsibility.

———◆———

601. Only those who do not comprehend the workings of the cosmos need to feel jealous.

———◆———

602. Do not confuse the actual with the real.

———◆———

603. Believing in the presence of God is like being on candid camera all the time.

———◆———

604. God will of course forgive us. But the question is: Are we prepared to forgive God?

———◆———

605. It is a sad fact, that in our world, publicity often counts for more than performance.

———◆———

606. It is an ugly realization that beauty may have no relationship to virtue.

———◆———

607. Virtue does not triumph on its own.

———◆———

608. For the tree to come up above the ground, the seed has to go under it.

———◆———

609. The more intelligent one is the more foolish one can be.

610. They say even God can't change the past. But historians can.

611. When we raise our hands to ask for God's help, we are already closer to heaven.

612. What is supernatural depends on our concept of the natural.

613. But for its potential universality, love would only be a form of partiality.

614. My love may not be perfect, but it is exquisite.

615. God is sometimes found in the gap between what one is and what one wants to be.

616. But for the anticipation, tomorrow will be like today.

617. Human beings live in the heart of other human beings, where else?

618. We don't realize what we are capable of until we get married.

619. Women need the morning after and men the evening before pill.

620. The two sides are never so close as they appear in peace or as far apart as they appear in war.

621. We become like the people we keep company with. And if you keep to yourself for too long, you become like yourself.

622. Family planning is the opposite of virgin birth.

623. Some have pointed out that hypochondria is also a disease, but it is about other diseases.

624. All things happen in space but nothing happens to space.

625. To confront reality is often to expose oneself to paradox, and to confront paradox is often to expose oneself to reality.

626. Being reasonable with unreasonable people is not very reasonable.

627. There is a difference between flip-flopping and zigzagging.

628. Different altitudes produce different attitudes.

629. Timing is everything. If the grenade goes off prematurely you are killed, if on time the enemy.

630. For a relationship to go anywhere the other shoe must drop.

---

631. Life is one long struggle against self-deception.

---

632. There is no better education than cognitive dissonance.

---

633. We fool ourselves when we think that we can't be fooled.

---

634. If we believe in an afterlife, then the fear of death may not vanish, but it would certainly become very amusing.

---

635. Evidence counts for more than truth in making our case to the world.

---

636. In the love of God time stands still.

---

637. Sometimes virtue can also be a temptation, like vice.

---

638. People don't find happiness because they seek pleasure.

---

639. You might then hate what you become, but you become what you hate.

---

640. The enlightened person is not necessarily a perfect person.

---

641. The scripture must remain the same, but must the interpretation of the scripture also remain the same?

---

642. Accuracy cannot be a substitute for authenticity.

---

643. God swings into action when you do.

---

644. The difference between the placebo effect and the miraculous cure is only one of degree.

---

645. An honest man will always let you know when he or she is telling a lie.

---

646. The art of living consists of knowing how far to go without going too far.

---

647. Just when we expect God to write lyrics he begins to compose blank verse.

---

648. Love ceases to be love when it ceases to be benevolent.

---

649. Virtue is more popular than wisdom because it is easier to feel virtuous than be wise.

---

650. You may doubt the existence of God but don't doubt his mercy.

---

651. Evil consists as much in lack of wisdom as lack of virtue. Wickedness consists only of the latter.

———◆———

652. One should make sure one is in the right lane before speeding up.

———◆———

653. You will make it in time if you don't walk too fast.

———◆———

654. Pursuing something with steadiness rather than eagerness is called yoga.

———◆———

655. Often a trip has to be undertaken to arrive where you already are.

———◆———

656. We tend to deal with people as we are, while we should deal with people as they are.

———◆———

657. How easily the flag becomes a shroud.

———◆———

658. Genocide leaves no room even for martyrdom. There is no community left to cherish it.

———◆———

659. Don't put pressure down. It transforms coal into diamond.

———◆———

660. Wisdom consists of the ability to convert hindsight into foresight.

———◆———

661. Human beings become more than human beings when they create, and less than human beings when they destroy.

———◆———

662. In the end, fragrance is all that is left of the flower and that too fades away.

663. Money may not be able to buy happiness, but can it rent it?

664. In order to receive what is offered to you, you have to let go of what you already hold.

665. Words express not only their meanings but also our psyche.

666. Doubt is God's way of disclosing a secret.

667. Failure only means that success will take more time than you had allowed for.

668. The price of hiring incompetent people far exceeds their salary.

669. Some things don't have to be precise to be true.

670. If the gods may be the product of our imagination, who is to say that we are not the product of the imagination of the gods.

671. The deeper the slumber the more vivid the awakening.

672. Separation is the longest distance between two people.

673. Virtue is its own reward even though it may not be much.

---

674. Goals are achieved by will rather than virtue.

---

675. Education consists in the intellectualization of doubt.

---

676. It is a strange argument that one should not prevent any robbery because one can't prevent all robberies.

---

677. We tend to feel as we think, and to think as we feel.

---

678. Bias is measured by the gap between evidence and conclusion.

---

679. The phenomenon of confession draws our attention to an important dimension of moral life: that virtue consists not so much in being incapable of sin, as in being ultimately incapable of deception.

---

680. No path is the right path if you don't know where you are going.

---

681. Truth never dies but it can become dormant.

---

682. The thing about truth is that even when you think you have found it, you must keep looking for it to be sure that it is not found somewhere else.

---

683. Life exposes our weaknesses and exalts our strengths.

---

684. One keeps good company by reading the great thinkers of the world.

---

685. Pain hurts both coming and going.

---

686. Two worlds come together when two people meet.

---

687. Being vulnerable does not mean being gullible.

---

688. Even the success which results from it cannot match the bliss of intense effort.

---

689. The maxim should not read: Do not hurt people, because you will. The maxim should read: Do not hurt people more than absolutely necessary.

---

690. Only a ray of light separates dawn from darkness.

---

691. A tree cannot grow upward without also growing downward.

---

692. Silences are hardest to translate.

---

693. It is not enough to be able to open the door. One must also make sure that it swings in the right direction.

---

694. The art of living consists of living without coherence while trying to achieve it.

---

695. God always gives us the best possible deal under the worst possible circumstances.

---

696. Fiction is the distance between the reader's credulity and the author's credibility.

---

697. Every choice between right and wrong is not necessarily a battle between good and evil.

---

698. Joy can condense a lifetime into a few moments, and sorrow can stretch a few moments into a lifetime.

---

699. When did we think our first thought?

---

700. An irrational God at times seems to offer the most rational explanation of the world we live in.

---

701. At most idealize, never idolize.

---

702. A garden is a jungle manicured.

---

703. It was one of those experiences which changes everything and yet leaves everything unchanged.

---

704. Patience is determination in slow motion.

———◆———

705. The problem is not really that we make mistakes, but that we persist in making them.

———◆———

706. Can one love without knowing, and know without loving?

———◆———

707. One needs humor to get through life, and perhaps death as well.

———◆———

708. It is the lever of the present with which one ultimately upends eternity.

———◆———

709. Happiness is what we are looking for while pleasure is what we get.

———◆———

710. We know some situations are bound to end in tears; what we don't know is whose tears they are going to be.

———◆———

711. A touch is worth a thousand words.

———◆———

712. You can both have your cake and eat it too, if it turns out to be bigger than what you thought it might be.

———◆———

713. It takes two hands to clap and only one to slap.

———◆———

714. The ship may still be sinking while the elevator is going up.

———◆———

715. When you fall down, make sure that you also pick someone else up as you rise.

716. According to one view, everything is nothing and nothing is everything.

717. Paradoxes resolve contradictions.

718. I know into each life some rain must fall. But does it have to be a downpour?

719. Flirtation is also blind.

720. Each loves the other more than the other in a truly loving relationship.

721. Why could the destiny not have been different?

722. All things happen in time but nothing happens to time.

723. Charity, without anonymity, is vanity.

724. By attempting the impossible one achieves the maximum of the possible.

725. The microscope and telescope are two opposite ways of enlarging our vision.

726. It is possible to be a saint without being enlightened.

727. Some commit suicide over a lifetime.

728. It is the perennial question of the desert: Is it an oasis or a mirage?

729. Grief can outlast pain.

730. Any hypothesis is a manifestation of hope.

731. Knowledge can overcome ignorance but not mystery.

732. Hope is the optimism of the heart.

733. The more tired you feel the more preordained everything seems.

734. It is love which converts a spasm into an orgasm.

735. It is as important to claim divinity in religion as it is to claim sovereignty in politics.

736. These are not one but three: the person, the persona, and the personality.

———◆———

737. It's a thin line between doing something spectacular and making a spectacle of oneself.

———◆———

738. Partiality is love without justice.

———◆———

739. A mirror shines like the sun, but only in the light of the sun.

———◆———

740. Is it possible to have commitment without attachment?

———◆———

741. Both weeds and plants grow in the same garden, nevertheless one eliminates the weeds to save the plants.

———◆———

742. First the dreamer is in the dream. Then the dream is in the dreamer. Then there is neither dream nor dreamer.

———◆———

743. The passage of time is the message of time.

———◆———

744. We are also confined by what we embrace or what embraces us.

———◆———

745. We all want to look but not to be caught looking.

———◆———

746. In trying to avoid commiting one error, sometimes we commit a hundred.

———◆———

747.  You cannot fight fire with light.

———◆———

748.  God is the IF in life.

———◆———

749.  Seek truth rather than certainty.

———◆———

750.  If she loves me she may be willing to do anything for me, but if I love her then will I ask her to?

———◆———

751.  What makes great men irritating is that in so many ways they are just like the rest of us.

———◆———

752.  Be sure to get what you like, lest you start liking what you get.

———◆———

753.  Sometimes a heart has to break to create the space for God to enter it.

———◆———

754.  Innocence is not incompatible with intelligence as it pertains to motive and not insight.

———◆———

755.  Unfortunately anger is not debatable.

———◆———

756.  When a person dies a whole world comes to an end.

———◆———

757.  We are all born the same way but die in different ways.

———◆———

758. Objects of nature, unlike human beings, do not have to understand the laws to follow them.

———◆———

759. Myths have changed history.

———◆———

760. As life grows longer it grows shorter, like a path.

———◆———

761. The Hindus have made one religion out of hundreds of gods, and the West has made three religions out of one God.

———◆———

762. Regretting is also a form of remembering.

———◆———

763. In the long run we are all reborn.

———◆———

764. Consciousness can be trapped but it can never be bound.

———◆———

765. Success is the gloss of effort.

———◆———

766. Sinning is an occupational hazard of living.

———◆———

767. Hope makes us feel less lonely without anyone else being present.

———◆———

768. How does one distinguish between temptation and opportunity. Temptation seems sweeter coming than going and opportunity seems larger going than coming.

———◆———

769. With women, love justifies everything; with men, passion.

770. Some truths cannot be told, only heard.

771. If the world lacks moral supervision, then it may be your duty to provide it.

772. The experiencer is more real than the experienced.

773. Why is it that, when we think of the happiest moment of our lives, they are invariably those when we loved most, or felt most loved.

774. Every revolutionary started out as a trouble-maker.

775. Praying may not change God's mind but it might change ours.

776. Asking God to intervene in the affairs of the world may be like asking the screen to intervene in what is going on in the movie.

777. The goal of education is to convert an empty mind into an open mind.

778. Intellectual openness always involves a certain measure of credulousness, but not forever.

779. Sometimes instant gratification can take a long time.

780. Only sincerity can draw the line between discretion and deceit.

———◆———

781. Life has a remarkable talent for identifying our weaknesses.

———◆———

782. The most important thing a human being ever does is to create another human being.

———◆———

783. The string of hope is never long enough.

———◆———

784. It is easier to be virtuous than to be wise, that is why we want to be judged by our intentions than by the results of our actions.

———◆———

785. Any claim to absolute truth must be tested on the anvil of extreme skepticism.

———◆———

786. The ultimate reality is a mystery but the real question is: Is it an auspicious or a suspicious mystery?

———◆———

787. The body experiences pain; it is the mind which undergoes suffering.

———◆———

788. What is the point of running through life if you are getting no traction.

———◆———

789. Sweet dreams and nightmares are both our own creation.

———◆———

790. No human being is perfect but every child is.

---

791. It is always 12 o'clock for the sun.

---

792. Afterlife consists of resumed conversations.

---

793. You need to choose only if you can't have it all.

---

794. Your mind should be where you are because you are where your mind is.

---

795. Whom or what are you going to remember when you are dying?

---

796. Tears can either blur one's vision or wipe it clean.

---

797. Two is not double.

---

798. Does pacifism mean that we do away with the police also?

---

799. Sometimes it is not given to us to know why, only to know how; sometimes it is not even given to us to know how, only to know who. Sometimes not even that.

---

800. Serious diseases cure us of minor ailments.

---

801. Just because someone is ignorant does not mean that the person is stupid.

———◦———

802. He is the kind of person who would attempt suicide in a hospital, so that he could get immediate medical attention.

———◦———

803. We may dream of limits, but there is no limit to our dreams.

———◦———

804. There is a difference between submission and acceptance.

———◦———

805. Live to learn until you learn how to live.

———◦———

806. Every generalist is in some measure a charlatan and every specialist an obscurantist.

———◦———

807. The art of living consists of converting dilemmas into choices.

———◦———

808. I saw the Titanic many times, and it sank every time.

———◦———

809. Faith is the triumph of belief over cognitive dissonance.

———◦———

810. It is not always clear whether someone is an upstart, or one on the rise.

———◦———

811. The lamp is there to give light. Who is to be blamed if someone uses it to start a fire?

———◦———

812. Always prefer truth to consistency.

———◆———

813. Even liquor poured in the Ganges becomes Ganges water, and even Ganges water mixed with liquor becomes liquor.

———◆———

814. Success goes to the head, but failure goes to the heart.

———◆———

815. Is the thorn there to keep the rose from being plucked?

———◆———

816. A date may be the beginning of a relationship, but a book is the beginning of a library.

———◆———

817. Hatred is the margin by which revenge exceeds justice.

———◆———

818. Better a life with unanswered questions than with unquestioned answers.

———◆———

819. Life may be a play and the world may be a stage, but does it have to be a tragedy?

———◆———

820. Parents mess up our life so much that it might be best to be born without them.

———◆———

821. You can convince the whole world but the question is: Can you convince your wife?

———◆———

822. It is easier to worship a religious leader than to follow one.

823. Those who hate us at least acknowledge our existence.

824. I don't believe in my country right or wrong. I believe in my country righting its wrongs.

825. There may be more beautiful women than my wife in the world, but in my world, my wife is the most beautiful woman there can be.

826. I prefer being stoic in victory to being stoic in defeat.

827. God is not beyond using atheism to achieve his or her ends.

828. Giving an answer is one thing, having an answer is another.

829. We hate people for their flaws but love them for their frailties.

830. Not every spiritual experience is spiritual.

831. Why try to change a system when a change in the system would do?

832. Nothing reveals our character more than how we treat the helpless.

833. Sometimes it is hard to tell whether one is being patient or simply wasting one's time.

834. That two wrongs don't make a right must have been said by the person who committed the first wrong and was about to be punished for it.

835. Life can sometimes be like an unlocked bathroom door.

836. One way to make the ends meet is to burn the candle at both ends.

837. Life is one long lesson, but in what?

838. Saints leave footprints just as criminals leave fingerprints.

839. One must bear the pain of one's wound while it heals.

840. Show anger if necessary but never feel it.

841. One has only to be sincere about one thing to realize the shallowness of everything else.

842. If you do not practise what you preach, it is best not to preach what you practice.

843. Life offers a constant choice between the splendor of the real and the glamour of the false.

844. God can be prosaic.

845. Failure only means that success will take more time than you had allowed for.

846. Never confuse single-mindedness with narrow-mindedness.

847. Truth should not be so true as to appear false.

848. The soldiers celebrate bravery, the politicians victory.

849. The fact that I oppose you does not mean that I hate you.

850. If knowledge can be encyclopedic, why not ignorance?

851. God cannot be partial if he is everywhere.

852. Politics is the art of not crossing invisible lines.

853. Nothing beats ordinary life for throwing up the extraordinary.

854. Failure is embarrassing, but seldom fatal.

---

855. More important than telling the truth about others is knowing the truth about oneself.

---

856. Never confuse breast-feeding with indecent exposure or wardrobe malfunction.

---

857. Is not being attached to all equally one form of being detached?

---

858. Nice guys end up last, smart nice guys walk away from the queue.

---

859. There are no atheists in foxholes and no theists in Auschwitz.

---

860. Give up hope if you must but effort, never.

---

861. Mystery provides for serendipity.

---

862. It takes two to forge a relationship and only one to break it.

---

863. A spoon is in constant touch with food but does not know its taste.

---

864. One may receive some light through a hole in the wall, more from a window and still more from an open door, but to be bathed in sunlight, one must ultimately come out of the house.

---

865. Affection neither demands nor requires perfection.

866. Ignorance is certain; doubt comes with knowledge.

867. All can be yours if you can be everybody's.

868. It is easier to be genuine than authentic.

869. If thoughts could feel and feelings could think.

870. The executioner also dies in the end.

871. At one level, nothing simplifies life as much as being told you are going to die; at another level, nothing complicates life as much.

872. Our greatest pleasure is in doing what we never thought we could.

873. The purpose of philosophy is to make us reflect on the obvious.

874. Some tears are not for shedding.

875. There is not much room for maneuver on a pedestal.

876. Darkness withdraws so gracefully in front of light.

877. We hold these truths to be self-evident: that all religions were created equal.

878. The petals fall away, the thorn stays.

879. Life creates more moral ambiguities than it can resolve.

880. Pretended illnesses require fictitious recoveries.

881. Does anyone anywhere know what's going on everywhere?

882. Cancer is not cancer to cancer. Poison is not poison to the cobra.

883. What we would die for, and what we would live for, are often two very different things.

884. God's love of drama sometimes makes us wonder about his love of justice.

885. A gentleman also always wants to win but only just.

886. Failure is success postponed.

887. Every country is not Russia, but everyone's life is like a Russian novel.

888. How many couples will marry each other again?

889. There are two ways of succeeding in life: one to swim with the tide, and the other is to swim against it.

890. If you wrestle with an angel long enough you may become one.

891. Success comes from the effort you make after you are tired.

892. The universe orients us but the universe is not oriented around us.

893. If winter comes, can spring be far behind? Yes, in Montreal.

894. When you go to beg, make sure that your bowl is empty.

895. The verdict of history is often the verdict of historians. Become one.

896. The art of living consists of turning tears into pearls.

897. The questions we ask intellectually sharpen our mind, but the questions we ask existentially deepen our soul.

898. If I knew what I wanted I would have got it by now.

899. Evil consists as much in lack of wisdom as lack of virtue. Wickedness consists only of the latter.

---

900. When all else fails, try love.

---

901. Darkness is only light switched off.

---

902. You get as far as you persist.

---

903. The superfluities of life are more devastating than its sins.

---

904. All languages are unsatisfactory because language is not what it describes.

---

905. What if the religious traditions of the world are locked boxes, each containing the other's key?

---

906. Spectators don't win trophies.

---

907. Does life have meaning, or do we give it meaning?

---

908. Whatever attracts, distracts.

---

909. The two greatest gifts are doubt and certainty, in the right place and at the right time.

---

910.  The secret of life is to have someone from whom one keeps none.

---

911.  Perfection is the enemy of completion.

---

912.  Sometimes one has to nourish one's vanity to keep one's ego in check.

---

913.  Marriage is an elaborate duel in which two people engage to assassinate each other.

---

914.  Don't let virtue ever tempt you.

---

915.  We learn most from those who differ most from us.

---

916.  God lets us know the how but not the why.

---

917.  A truth told with bad intent, is more dangerous than a lie.

---

918.  God is a great guy but hides it well.

---

919.  The course of true hatred does not run smooth either. One sometimes feels like forgiving the enemy.

---

920.  What is will without goodwill?

---

921. If you are running on a treadmill you will never reach the top.

922. The fact that we can do without food for a day does not mean that we can do without it forever.

923. In order to triumph, you need opposition.

924. News changes views.

925. The greater the obduracy, the more abject the surrender.

926. It begins with stereotypes and ends with demonization.

927. The greatest punishment of liars is not that nobody believes them but that liars can't believe anybody.

928. The art of living consists in managing contradictions.

929. Sometimes what we think of as morality is only psychology masquerading as such.

930. Necessity is the mother not only of invention, but also of lying.

931. There are no illegitimate children, only illegitimate parents.

932. Avoiding the discomfort of struggle is the worst form of idleness.

933. Truth, when exaggerated, loses some of its power.

934. Life is one long negotiation between self-effacement and self-assertion.

935. No one ever died of hypochondria.

936. If you fail, aim higher.

937. We learn not from what we hear but what we heed.

938. Antiquity does not guarantee continuity.

939. Hurrying is a form of greed.

940. The trouble with teaching someone a lesson is that one may end up having to learn one oneself.

941. These are two equally beautiful moments: when a love begins and an enmity ends.

942. Everything that happens to us will seem like an act of grace, if we have no expectations.

943. Do we do good and then become happy, or do we become happy and then do good?

———◆———

944. God has been over-advertised.

———◆———

945. We want our religions to be perfect, and our religions want us to be perfect.

———◆———

946. Never confuse motion with action.

———◆———

947. Women weep because they know that suffering is more eloquent than words.

———◆———

948. Philosophy is as much about finding questions, as about finding answers for them.

———◆———

949. The secret of life is to have no secrets.

———◆———

950. Just as technology is the proof of science, spirituality is the proof of religion.

———◆———

951. It is up to you to make life a request, a quest, or a conquest.

———◆———

952. Cancer is impervious to virtue.

———◆———

953. Everything is true until it is questioned.

———◆———

954. Don't start another battle if you are already winning the war.

955. If we want a painless life, then let us remember that cancer is also painless to begin with.

956. If you are not happy now, when will you be?

957. A wave is distinguishable from the ocean, but it is not separate from it.

958. Never confuse stability with permanence.

959. Before you start climbing up the ladder, make sure it is up against the right wall.

960. It used to be love at first sight, now it is lovers at first sight.

961. If Christianity is faith seeking understanding, modernity is understanding seeking faith.

962. We rarely solve problems; we usually exchange one set of problems for another.

963. A vigorous half-truth outstrips a lazy truth.

964. The secret of romance is playfulness without possessiveness.

965. Of all burdens, that of pretense is perhaps the hardest to bear.

966. Should one not blow one's own horn if it produces good music?

967. Is the flower yellow, or do I have jaundice?

968. Sometimes the fruit falls on the other side of the fence.

969. Truth, when it needs others to help it prevail, becomes justice.

970. If we are too involved in the dream, we may not realize that it is a dream.

971. If panic can spread, courage can also be contagious.

972. One has to be inspired to be inspired.

973. Asymmetry is the beginning of inequality.

974. Our virtues make us vulnerable in dealing with the wicked.

975. Youth tries to change the world, and then the world changes the youth.

976. Tears are liquid words.

977. Every attraction is a distraction.

978. Would we have left the womb, if we knew what life would be like?

979. Familiarity generates the illusion of knowledge.

980. The truth of one religion proves the truth of the other.

981. Something can be wholly true, and yet not true of the whole.

982. The very originality of the idea can sometimes prevent it from making an impression.

983. Who invented water?

984. Some problems cannot be conquered, only besieged.

985. The exploits of the imperialists, and the exploitation of the subjects, are often two sides of the same coin.

986. Many answers may be correct, but only one may be right.

⸻◆⸻

987. One who confronts a paradox exposes oneself to reality.

⸻◆⸻

988. Something may be presently incomplete; this does not mean that it is inherently incomplete.

⸻◆⸻

989. Does our intellectual life consist of dogmas to be defended, or hypotheses to be tested?

⸻◆⸻

990. What if a couple got divorced and then answered each other's anonymous ads? Ah, What then?

⸻◆⸻

991. Are we characters in a novel or a movie, who can't change their character?

⸻◆⸻

992. Conversion cannot be a substitute for coexistence.

⸻◆⸻

993. Freudian analysis deals with hang-ups, but Freudism itself seems to have become the great hang-up.

⸻◆⸻

994. Can nature not be cajoled to yield its secrets, must it be tortured?

⸻◆⸻

995. What we actually get in life is the intersection between merit and politics.

⸻◆⸻

996.   God reveals himself on a need to know basis.

997.   Don't guess—seek clarification.

998.   Only if you think the unthinkable will you be able to do the undoable.

999.   Love is one way of neutralizing hatred. Power is another.

1000.  We talk of the inevitability of death, have we ever spared a thought for the inevitability of life?

1001.  If we speak of the valley of death, then we must also speak of the mountain of life.

1002.  When you dance, the frayed hem of life is lifted.

1003.  We are not escaping from hell if our escape is restricted to ourselves.

1004.  Don't let being bitter come in the way of being better.

1005.  What insulates need not always isolate.

1006.  Life does not always offer as many options as the Kama Sutra.

1007. Resurrection puts your flesh through a second existence, reincarnation does that to your soul.

———◦———

1008. People say that one should not suspect a deathbed confession, but what if it comes from a suspect who believes in reincarnation?

———◦———

1009. It is we that are blind, not love.

———◦———

1010. The West believes in the inevitability of death, India believes in the inevitability of life.

———◦———

1011. There is a world of difference between saying that this is true, and saying that this alone is true.

———◦———

1012. The problem with pain is that it is painful.

———◦———

1013. Could it be that what is happening here has already happened somewhere?

———◦———

1014. When we look at the world the way it is, the only choice is between going mad or becoming a philosopher.

———◦———

1015. One should neither personalize the public nor publicize the personal.

———◦———

1016. In the end, there is only you and God and; if you are an atheist, only you.

———◦———

1017.  Is it possible to live without hurting others?

1018.  It sometimes takes a major tragedy to make us realize the fragility of our lives.

1019.  You cannot be a hero and a Hamlet at the same time.

1020.  A romance is a gallant protest against the dullness of life.

1021.  When people laugh at my jokes, I am never sure whether they are laughing at my jokes or at my attempt to crack one.

1022.  Every advance also possesses an element of retrogression.

1023.  The tortoise won the race against the hare, but what if there was another tortoise in the race?

1024.  Desiring is a waste of time, and fantasizing a waste of energy. Aspiring is better than both.

1025.  One need not know how the world came to be, to enjoy being in it.

1026.  We cannot really understand mainstream history without knowing those who challenge it.

1027. It is always a healthy exercise not to try to explain a phenomenon from an extreme or rare version of it, but to explain the rare or extreme version from the phenomenon itself.

1028. I would not mind not being a great man, if I could do a great thing.

1029. Success and failure exaggerate the difference between human beings.

1030. Each of us is so unique that we even laugh and cry in our own way.

1031. An epic starts with one verse.

1032. Virtuosity without sincerity gets everywhere and nowhere.

1033. The world counts for more than you.

1034. The wave is less and the ocean is more, but the wave has to let go of even what it has to become more.

1035. Is God's attempt to create human beings a failed attempt at humor?

1036. One thing can be invariably associated with another, yet not be the cause of other.

1037. Come, I will suffer with you.

1038. A true atheist believes in himself.

1039. A good translation has to be both faithful and beautiful.

1040. Is there anything in your life you will do anything to get?

1041. You are the wall between you and the ultimate reality until you realize that you are the ultimate reality.

1042. You may have come from God but the next meeting is not scheduled until the end of the world.

1043. Our lives are looser storylines than our biographies might suggest.

1044. Rebirth means that we get a second chance to make a first impression.

1045. Sometimes I felt, sitting in a class at a university, that I was getting educated beyond my intelligence.

1046. If you are living your vows, you can forget them.

1047. We feel only as safe as our secrets.

1048. If life lacks substantiality, as Buddhists argue, then style is everything.

———◆———

1049. Myths could be things which never happened but are always true.

———◆———

1050. Apposition can be more powerful than addition. One plus one makes two, but two ones, side by side, make eleven.

———◆———

1051. Every door, if closed, is a wall.

———◆———

1052. Arriving at conclusions is easy. Conviction is more difficult to come by.

———◆———

1053. Life is sometimes so complex that it becomes entertaining.

———◆———

1054. Scholarship consists in not telling half-truths, unless they are completely accurate.

———◆———

1055. The secret of relaxation is to be able to hang loose without dropping out.

———◆———

1056. Hippie values may not be consistent with a yuppie career.

———◆———

1057. I may be in a holding pattern but I don't know if my pattern is holding.

———◆———

1058. Trying to do it while sitting in a chair may be too casual an approach to the lotus posture.

—————

1059. I am in favor of any experience which stretches you without breaking you.

—————

1060. Every window is a mirror.

—————

1061. Intelligence consists in being able to make fine distinctions.

—————

1062. Presence of evidence is not always evidence of presence, and "absence of evidence not always evidence of absence."

—————

1063. Sometimes I know what I want to say but do not have the word to say it.

—————

1064. Tactical moves should never be confused with ideological orientations.

—————

1065. The grass may appear to be greener on the other side because it is better watered there.

—————

1066. Is it true that Hebrew and Greek do not have a word for consciousness?

—————

1067. A wave appearing on the ocean reminds one of individuality emerging from totality.

—————

1068. The drag of the past and the pull of the future can make the present come apart.

——◆——

1069. The problem with potentiality is that it is often invisible until it manifests itself.

——◆——

1070. If you understand something better, you experience it better.

——◆——

1071. Discipline is important because efficiency is the controlled release of energy.

——◆——

1072. Although our branches may mingle, our roots are our own.

——◆——

1073. We often feel compassion when a kind deed is *done*; but the truly sensitive feel compassion for the process itself.

——◆——

1074. We do not know the many who could never become what they could, because potentiality has no witness.

——◆——

1075. When you call it Kantian or Hegelian, it begins to sound impressive.

——◆——

1076. If there is such a thing as intelligence, is there such a thing as extelligence also?

——◆——

1077. If all of us started speaking at length, none of us will be able to speak at all.

——◆——

1078. Have we ever understood why saints marvel at the divinity of daily experience?

---

1079. Life teaches us how to do things, but has a tough time teaching us how to undo them.

---

1080. Sometimes the baby may deserve to be thrown out with the bathwater.

---

1081. One should only help someone along the way, so long as one does not have to go so far out of the way as to lose one's way.

---

1082. If the shoes do not fit, it will give you a corn.

---

1083. Forgetfulness can have structures as deep as memory.

---

1084. We have the wisdom of tradition when we have a tradition of wisdom, not otherwise.

---

1085. Structures of thought will never be free from the strictures, the limitations of thought.

---

1086. Our introductions have a way of making us sound better than we are.

---

1087. Comparisons can confuse as often as they clarify.

---

1088. Concealment may be a part of the dynamics of revelation.

1089. When a lie becomes an established academic practice, it may take more than the truth to undo it.

1090. Will a prison remain a prison if one had an epiphany in one?

1091. It is quite possible to get rid of colonies without getting rid of colonialism.

1092. If one is freed, but the mind is not free, freedom may only end up in stagnation.

1093. There is a difference between being in prison, and being imprisoned.

1094. Those who would navigate by the polar star may need to remember that the polar star also shifts.

1095. Sometimes one needs to change the goal, not just the goal post.

1096. History may not be myth but myth has been known to change history.

1097. Circles need to become spirals to move forward.

1098. The ineffable may not be ineffable as when we say "I have no words to express my gratitude"; we just expressed it in words.

1099. While criticizing imperialism, Marxism sometimes slips into exegetical imperialism.

1100. It is perhaps a form of narcissism that Puritans end up enjoying their own Puritanism.

1101. Facts pertain to details; truth to the whole picture.

1102. History is precedent but past is prologue.

1103. History, even when recursive, is never fully predictive.

1104. A whiff of mortality can do wonders for morality.

1105. We should pair off false hopes with imaginary fears and send them both packing.

1106. It is always possible to be better; even in doing something illicit, it is possible not to be sordid.

1107. Deep disquiet is to be preferred to cheap indignation.

1108. A profound person has answers, to questions which may not even exist at the moment.

—————

1109. Isn't it something of a paradox that one can have accurate reports of inaccurate reporting.

—————

1110. Can equality ever be fully reconciled with individuality?

—————

1111. I saw her sitting on the couch of conceit in the chamber of charm, seduced by the beauty of her own magnificence.

—————

1112. Modern economy has become as much a mechanism for creating a need as for meeting a need.

—————

1113. What arises out of something also has some obligation to move beyond it.

—————

1114. Loving people in real life is much more difficult than loving them in abstraction.

—————

1115. Does being respectful mean always being in harmony?

—————

1116. Only the pure can purify.

—————

1117. Purity runs the risk of being barren, just as gregariousness runs the risk of promiscuity.

—————

1118. The only thing that detracts from the greatness of a saint is if he or she did not make the right kind of enemies.

1119. One should beware of an excess of virtue as much as of vice.

1120. The power of prophecy can come as much from analysis as from divine inspiration.

1121. Beware of not just Greeks but anybody bearing gifts.

1122. The opposite of a profound truth can also be a profound truth; it need not be error.

1123. The problem with specialization, or knowing more and more about less and less, is that it might let the great truth escape.

1124. Before you claim a fair share of the pie, make sure that the pie is worth eating.

1125. I prefer the description of God as mother, rather than as father, because maternity is a fact and paternity, after all, is a presumption.

1126. A secularist stands on the shores of a tradition. A believer swims in the waters of the tradition. A fanatic drowns in it.

1127. What is nice is not always good, and what is good is not always nice.

———◆———

1128. Just as there is no such thing as a free lunch, there is no such thing as a free market.

———◆———

1129. We need Heaven, because we need a unifying dream in the face of a collective nightmare.

———◆———

1130. Leadership is a hundred little things leading to a big thing.

———◆———

1131. Evil, while sufficient, is not necessary for the existence of suffering.

———◆———

1132. Karma may be a question of the relationship of truth and consequences, as much as of virtue and consequences.

———◆———

1133. The point about the Hindu concept of Samsara is that although about journeys, it goes nowhere.

———◆———

1134. What are your million dollars worth if you have no one worth a million dollars to go with them?

———◆———

1135. If you cannot be a rival, try to be a successor.

———◆———

1136. Casualness is the affectation of perfection.

———◆———

1137.  Sometimes one cannot allow oneself the luxury of self-doubt.

1138.  An indifference to culture might explain our culture of indifference.

1139.  What should one do when failure stares us in the face? Stare back until it blinks.

1140.  Everything is changing; only the rate of change is different.

1141.  Is the essence of a thing identical with it, or different from it?

1142.  Ultimately it all boils down to the right attitude.

1143.  Disappointment and jealousy arise from a false view of the world.

1144.  Fear of death keeps us alive.

1145.  It is a thin line which separates recklessness from enthusiasm.

1146.  The relationship between pride and modesty can be subtle; one can be proud of being modest, and one can be modest in one's pride.

1147.  Too many shining lights can become a blinding glare.

1148. If one was to be a true scholar—one who takes all the evidence on an issue into account, and examines it from all points of view—one will be able to offer just a few conclusions and sometimes only one, or even none.

1149. Who has the human right to talk about human rights?

1150. We do not lose things in life so much as leave them behind.

1151. Wisdom is more important than either virtue or vice.

1152. It is true that one should talk no ill of the dead, but the results of a person's actions often become apparent only after the person has passed away.

1153. Those who study a tradition, without taking those who follow it into account, seem to be bent on looking at the reflection of a person in the mirror, while standing next to the person.

1154. Sometimes the mirror, which is being held up to reflect reality, can reflect too much of the person holding it.

1155. A closed mind saves time but forecloses understanding.

1156. Facts can obscure the truth.

1157.  Objectivity can be a search for fact, or truth, or reality, but these terms may not be synonymous.

———◆———

1158.  Everybody has the right to speak, but that does not mean that everybody has to be taken seriously.

———◆———

1159.  Things can be more true than real.

———◆———

1160.  If I say "I dreamt of God," I am relying on reason; but when I say "God appeared to me in a dream," I am relying on revelation.

———◆———

1161.  Is it the rising sun, or the setting sun?

———◆———

1162.  To be afraid of death is like being afraid of sleeping.

———◆———

1163.  We generalize at the cost of nuances; we nuance at the cost of generalization.

———◆———

1164.  Some things may possess a quality beyond its contents, and others may possess contents beyond their quality.

———◆———

1165.  Every hope has the potential of becoming a religion, and every religion has the potential for providing hope.

———◆———

1166.  When we speak of difference between things we imply either that each of them is itself, (because it is not the same as the other), or that each of them is different, (because each of them is only itself).

———◆———

1167. We are all one of course not numerically, but teleologically.

1168. At what point do points begin to form a pattern?

1169. Does the fact that we belong to different religious communities mean that we also belong to different moral communities?

1170. The moment we turn something into a concept we create a distance from it.

1171. Problems are sometimes solved by pushing them to another level.

1172. We do not so often solve problems as exchange one set of problems for another.

1173. No matter how endlessly we may try to defend it, imperialism never quite loses its self-justifying character.

1174. To say something is beyond good or evil does not mean that either may not come from it.

1175. To pull something out of its historical context invariably flattens it.

1176. Lovers and friends do not always share certainties, they also share ambiguities.

1177. The problem with being accommodationist is that you end up accommodating more than what you bargained for.

1178. Often what is invisible on the inside is apparent from the outside.

1179. What can the five fingers achieve if separated from one another.

1180. A total explanation may not be the ultimate explanation.

1181. What is final may not be ultimate.

1182. It is better to say that each religion is superior to the other, than to say that each is inferior to the other.

1183. Life both builds and reveals character.

1184. You turn to a friend for support but to a sage for illumination.

1185. The origin of a thing could be particular, and yet its significance could be universal.

1186. I have a modest ego.

1187. Everyone wants to go to heaven but also wants to live on this earth as long as possible.

1188. If you see through a thing, then what do you see?

---

1189. Is it exactly progress if we turn a wasteland into a flatland?

---

1190. The problem with being an autodidact is that you have no one to blame for your ignorance.

---

1191. If curiosity killed the cat, who killed the mouse?

---

1192. We often exempt ourselves when we criticize others for their failures.

---

1193. All bad things come to an end.

---

1194. If you have to tell someone you are famous, then you are not.

---

1195. The two most important days of your life are when you were born, and when you found out how.

---

1196. Blame the cause, not causation.

---

1197. Don't blame gravity for falling.

---

1198. Human beings are basically good; therefore, all interpersonal failures are failures of humanity.

1199.   The ability to meet the challenge is sometimes generated by the challenge.

———◆———

1200.   Why do we exempt ourselves when we say people are foolish?

———◆———

1201.   Sweets are a mouthwatering thought.

———◆———

1202.   A good writer can describe events so vividly that they become alive for the readers, even when the lines are fictional.

———◆———

1203.   We have overcome an emotion when we can describe it unemotionally.

———◆———

1204.   Being unruffled has a strange side effect—it can ruffle others.

———◆———

1205.   If someone monopolizes the microphone, what option does one have except to monopolize silence.

———◆———

1206.   If there is no sin, then there is no sinner. If there is no sinner, then there is no sin.

———◆———

1207.   Sometimes one cries because one can't.

———◆———

1208.   Why are the lightest coffins the hardest to bear?

———◆———

1209. Deja vu all over again can itself deja vu all over again?

---

1210. Inhumanity should serve as the limit of conformity.

---

1211. All support should not be welcome. The rope also supports the hanged.

---

1212. Anyone who plays the role of an umpire cannot avoid playing the role of an arbiter to some extent.

---

1213. History is an attempt to wrest meaning out of our collective experience, just as biography is an attempt to wrest meaning out of personal experience.

---

1214. A necklace is not lost when the pearls are lost, it is lost when the thread is lost.

---

1215. If you expect nothing, everything is a surprise.

---

1216. The prosperous can lead a life of euphemisms, not the poor.

---

1217. How can the future slip away? Our hopes slip away, never the future.

---

1218. Every human being is an occasion for universal hope.

---

1219.  The goal may be vague but the hardships are real.

1220.  Some are revolutionaries; some are the revolution.

1221.  All that glitters is not gold—it may be a gem.

1222.  If we must suffer to learn, then we will have to learn to suffer.

1223.  Giving advice gives you power without responsibility, leaving the other person in the opposite situation.

1224.  It is better to have power without authority than to have authority without power.

1225.  Politicians are provocative; poets evocative.

1226.  Love, to be real, has to last, because what lasts is more real than what doesn't.

1227.  Sometimes votes don't count as much as who counts the votes.

1228.  Time itself is a great teacher.

1229.  Tolerance is not the same as freedom.

1230. Could it be that, just as we struggle with God, God also struggles with us?

1231. To what extent can we be open to what is not open?

1232. Anything that leads to a greater self-understanding of what it means to be human, should be welcomed by every human.

1233. Any point, carried beyond a certain point, can become nauseating.

1234. The state protects one individual from another individual; human rights protect the individual from the state, but who protects one state from another?

1235. Do we realize that 60,000 cerebral events take place every day in our mind. Sounds much more impressive than saying sixty thousand thoughts pass through our mind every day.

1236. If everything is random, then let us commit random acts of kindness; and if everything is predetermined, then let us commit predetermined acts of kindness.

1237. What a letdown if the most romantic experiences of our life end up being the most didactic.

1238. It's not what you know, it's not whom you know, it's not who knows you; it is who knows?

1239. You must know two things in life—where your song comes from, and where your sigh comes from.

1240. You only really own what you give to someone else.

1241. Kites rise by going against the prevailing wind, sails rise by going with it. Choose what you want to be.

1242. Will you go through life anesthetized by ambition or sensitized by sentiment?

1243. Here is a title for an autobiography: Time, Space and Imagination.

1244. Seek perfection that you may attain excellence.

1245. Isn't conscience also a way of knowing?

1246. Do computers have a religion?

1247. Have you ever sat quietly listening to unheard melodies?

1248. We gaze at the stars and wonder, but have we ever tried to peer at the immensity within all of us?

1249. I know I am mortal, but I don't quite know what to do with that fact.

1250. What is not said can sometimes speak very loudly.

1251. Part of getting ahead unfortunately means leaving others behind.

1252. What you think of someone else is part and parcel of your relationship with the person.

1253. Truth is hard to accept sometimes. I see the sun going round the earth; how am I to reconcile it with the fact that really it is the earth which is going round the sun?

1254. Celibacy is great, but it could also lead to prostate cancer.

1255. One should always try to spiral out of a cycle.

1256. Is God to be seen with eyes closed?

1257. If two revelations conflict, we turn to reason; if two 'reasons' conflict, we turn to revelation.

1258. Is understanding something, an act or a fact?

1259. We are like ciphers who may not count for much by themselves, but count for a lot with other figures.

1260. Interpret yourself first.

1261. It is easy to be perfect without being comprehensive.

1262. The only problem with being dignified is that it becomes a full-time occupation by itself.

1263. Something may be true of the parts but not of the whole.

1264. Two things can be invariably connected but yet not be the cause of the other.

1265. Something can appear to be fully true, and yet be totally false.

1266. A thing may be abominable in its origin but reasonable in its manifestation.

1267. Some are flattered by the fact that someone thought of flattering them.

1268. Truth is that which explains the facts.

1269. Do those who create literature realize that one day life may imitate literature?

1270. Being famous and being popular are two different things.

1271. Two things may be indistinguishable and yet not identical.

1272. Pray, and let pray.

1273. Where are the hidden chambers in the bicameral mind?

1274. Multiple illusions are easier to deal with than multiple realities.

1275. Someone does not become an insider just by being inside the house.

1276. Somehow we tend to think that what is incredible is infallible.

1277. History is not a monument, it is a movement.

1278. I would rather be wrong than ignorant.

1279. Many a poet sets out to write an epic, but ends up writing a poem.

1280. The truth can sometimes be strangled by facts.

1281. Do we have knowledge of what knowledge is?

1282. Are we conscious of what consciousness is?

1283. Indology may be only as useful for Indians as ornithology is for birds.

1284. A lie does not always have to be spoken; it can also consist of the things not said.

1285. The challenge in writing a paper is always to make it complete without making it exhaustive.

1286. Brevity is of course a virtue, but in our age it is also a necessity.

1287. The bane of modern reporting is the confusion between information and interpretation.

1288. The problem with reading writings about a culture is that cultures are also "communities" of "interpretation," so one is never sure when the outsider has started interpreting the interpretation, or worse still, started one's own interpretation.

1289. Life is as much about ordering experience, as about understanding it.

1290. Modernity has a way of putting one's beliefs out of action, without us ceasing to believe in them.

1291. The problem with the relations between men and women is that the two are both parallel, as well as antithetical to each other.

1292. Something may be found within a system, but it may still be peripheral to it.

1293. A human being may be said to extend as far as his or her fame.

1294. Classification per se is not discrimination.

1295. That human beings are one is a philosophical rather than an anthropological discovery.

1296. If truth remains too elusive, then it engenders the suspicion that it is hiding something.

1297. What bothers us about the flux is not so much the fluctuation as the uncertainty.

1298. Even identity finds it hard to be itself. The same color may appear different with different lighting.

1299. Is the tradition changing, or is the context changing?

1300.  It is possible to see something particular by itself, but is it possible to recognize it as particular without some conception of the general?

———◆———

1301.  The problem with being blunt is that it is also blunting.

———◆———

1302.  Two can strengthen each other as much as undermine each other.

———◆———

1303.  There may be no purpose in life; it may be there to be repurposed.

———◆———

1304.  To find the secret of Karma, one has to think beyond Karma.

———◆———

1305.  Who would have thought, in the midst of darkness, that the sun would emerge from the womb of that darkness.

———◆———

1306.  When you don't find something you are looking for, look for it in the finding of it.

———◆———

1307.  If the wave calmed down, it would cease to be a wave.

———◆———

1308.  The West universalizes the parochial; India parochializes the universal.

———◆———

1309.  One does not burn down one's house to feel warm.

———◆———

1310. To find the meaning of morality, one must think beyond morality.

———◆———

1311. When one has only one choice, then one can say that the person made the choice, but one can also say that they had no choice.

———◆———

1312. Those steeped in hierarchy, also think of a hierarchical paradise.

———◆———

1313. Even a dark prophecy may not be as dark as it seems, because the future is always open.

———◆———

1314. Some things may not be corrupt in themselves, but may still be corrupting.

———◆———

1315. Sometimes fighting a behemoth can also make you one.

———◆———

1316. That it might lead to a kind of robotic detachment is the flip side of discipline.

———◆———

1317. Could we not say that two subatomic particles are in love with each other, if "once they come in contact will remain subtly entangled no matter how far they are separated in space."

———◆———

1318. I am looking for an unmonetized relationship in life.

———◆———

1319. An elevator cannot take you to heaven.

———◆———

1320. A tepid curiosity can easily be mistaken for a timid curiosity.

———◆◆◆———

1321. The confected outrage of somebody is best met with affected sympathy.

———◆◆◆———

1322. There is a tendency for our electronic footprint to become larger than our feet.

———◆◆◆———

1323. Living one's life is like reading a novel—whose plot we don't know.

———◆◆◆———

1324. Nihilism is something you can flirt with, but never embrace.

———◆◆◆———

1325. Optimists mistake the floor for the ceiling and pessimists the ceiling for the floor.

———◆◆◆———

1326. There are things which disappear when you define them.

———◆◆◆———

1327. Many a resolution has disappeared in the gap between intention and action.

———◆◆◆———

1328. The thread of comprehension may get snarled, so long as it does not snap.

———◆◆◆———

1329. Who has not rued that sudden transition from hope to heartbreak in a contingent world?

———◆◆◆———

1330.  A compulsion is not a decision.

———◆———

1331.  Am I being selfish if I try to save my life?

———◆———

1332.  One who has no plan is always at the mercy of one who has.

———◆———

1333.  Why are people worried about old age, when one would rather exist than not?

———◆———

1334.  How could one possibly know that one did not exist?

———◆———

1335.  Sometimes one can see one's reflection even in a telescope.

———◆———

1336.  Half the art of teaching consists of making it interesting.

———◆———

1337.  Life can be full of situations which are desperate without being serious.

———◆———

1338.  An appropriate anecdote is worth a thousand lectures.

———◆———

1339.  Some things which happened a long time ago seem recent, and some things which happened recently seem to have happened a long time ago.

———◆———

1340.  Falling in love in old age allows one to be juvenile and senile at the same time.

———◆———

1341.  It would be extraordinarily eccentric to deny one's own existence.

---

1342.  A woke culture compels one to seek an uncontaminated identity, but does one exist?

---

1343.  Should one not prefer bold arrogance to cowardly equivocation?

---

1344.  The journey of a thousand miles no doubt begins with a single step, but that step must be taken in the right direction.

---

1345.  In the stormy passages of our life, it is sometimes difficult to tell the difference between flashes of heavenly lightning and human artillery.

---

1346.  There are two aspects to our life—the telescopic and the microscopic. I know of no one who has been able to fuse these two perspectives perfectly. Suffering may be the result of our inability to do so.

---

1347.  The moment of emotion, all too often, captures only the emotion of the moment.

---

1348.  A thing may change itself, qualitatively or quantitatively, so much that it ceases to be itself.

---

1349.  We often confuse the pleasant with what is good, and the unpleasant with what is bad.

---

1350. Even the thought of death can be a distraction, for the one leading a life of supreme concentration.

---

1351. An enabling condition is almost always a limiting condition.

---

1352. What object in the world could be more mysterious than one's own husband or wife?

---

1353. Some things cannot be defined, they can only be experienced.

---

1354. The only sin in the world is to crush someone's spirit and the only virtue is to raise it.

---

1355. Freedom requires discipline; total freedom requires absolute discipline.

---

1356. Disasters often come as offers.

---

1357. The reason why egoism is so popular is that it leaves one accountable only to oneself.

---

1358. We do not know who will throw the first stone, but there is always someone ready to throw the second one.

---

1359. Being disinterested is not the same as being uninterested.

---

1360. Nice guys don't just end up last. They just end.

1361. Only a very fine line separates anthropocentrism from humanism.

1362. We are brought up by our parents but we are also sometimes brought down by them.

1363. If you are not doing the right thing, you will not be able to do the thing right.

1364. Life, even when it is being lived with vigorous commitment, must be analyzed with rigorous detachment.

1365. Telling the truth is easier than listening to it.

1366. Why does injustice arouse our emotion more than our reason?

1367. It is as important to feel clearly, as it is to think clearly.

1368. Justice delayed is justice denied, but one would not wish to rush to judgment either.

1369. A religious tradition which has ceased to inspire deserves to die.

1370. The sage only experiences; others experience joy or sorrow.

1371. One way to end self-deception is to eliminate the self from it.

---

1372. One achieves the impossible by doing all that is possible.

---

1373. God is in the thick of events.

---

1374. How far does one go by taking the low moral road?

---

1375. We marvel at the world that exists outside us. Have we ever paused to marvel how much exists inside us?

---

1376. Just because something is more difficult does not mean that it is more virtuous or effective.

---

1377. If one thinks less of the burden, and more of how it might be borne, the burden becomes less.

---

1378. How we look at other religions all depends on whether one's religion provides a see-through glass or a stained glass to look at them.

---

1379. Even light can cast a dark shadow.

---

1380. A remote control could also be working within us.

---

1381. A loss of grade may mean a loss of glory but it leaves our understanding of the subject unaffected.

—◆—

1382. How much energy should we invest in the moment, if it is going to disappear so soon?

—◆—

1383. Does the weather determine your mood, or does the mood determine the weather?

—◆—

1384. If what you do is a function of who you are, then what you are can also be a function of what you do.

—◆—

1385. Classification carries with it the risk of calcification.

—◆—

1386. Can anything function as a cause without itself undergoing change?

—◆—

1387. When consciousness is conscious of itself, it is a person; otherwise it is a principle.

—◆—

1388. One can divide people intellectually to rule over them politically.

—◆—

1389. That something is ancient does not mean that it is permanent.

—◆—

1390. All hegemonies are resented, but is it because they arouse jealously?

—◆—

1391. That everything has a shadow side does not mean that it is always a dark side.

———◆———

1392. What shocks us most is what we are least capable of imagining.

———◆———

1393. Although a doctrine may not be judged by its deviation, that deviation should be factored into our understanding of it.

———◆———

1394. The more baseless the accusation, the more base it is.

———◆———

1395. Is there any way of judging a tradition except by looking at the kind of people it produces?

———◆———

1396. We will not be moved by an emotion, if we felt manipulated.

———◆———

1397. Most attacks on rituals are directed at the hypocrisy surrounding it, rather than at it as such.

———◆———

1398. One must remember, while discovering a pattern, that specific cases can be as significant as any generalization.

———◆———

1399. People tend to take their own traditions liberally and those of others, literally.

———◆———

1400. It is striking that conflicting stereotypes about people can be held simultaneously if we don't like them.

———◆———

1401.  There is no sex without life, and there is no life without sex.

———————

1402.  Who has also not felt the joy of sorrow, and the sorrow of joy.

———————

1403.  Discomfort is not disaster.

———————

1404.  The most important piece of evidence is that which goes against a thesis.

———————

1405.  Not all that is said is heard, and not all that is heard is said.

———————

1406.  The search for truth has no expiry date on it.

———————

1407.  How can we know something existed if it disappears without a trace?

———————

1408.  All knowledge is surrounded by a wall of ignorance.

———————

1409.  That one should not be attached to the fruits of one's actions does not mean that one should be negligent of them.

———————

1410.  A leader emerges when that person's subjective compulsions coincide with objective reality.

———————

1411. The entire truth belongs neither to you nor to me. It either belongs to both of us or lies in-between us.

1412. Divine grace is elastic, but not infinite.

1413. One may care more for God than the images of God, but that need not make one look down on the images of God.

1414. What is truly sublime also sublimates.

1415. Not everything that counts can be counted.

1416. The lion may lie down with the lamb, but for that to happen the lion will have to become a vegetarian.

1417. What is history for some may be living memory for others.

1418. Was what I just said ingenious or absurd?

1419. Never ignore the substance of what is said by questioning the motivation.

1420. Not everything that is counted in can be counted on.

1421. To define something by its worst features is to confine something to its worst features.

————◆————

1422. There is a subtle difference between describing a union as a "gay marriage" and "a marriage that happens to be gay."

————◆————

1423. Just as weakness can be magnified by fatigue, failure can be magnified by despondency.

————◆————

1424. An aperture is enough to let in light.

————◆————

1425. The frustration that we live our lives suboptimally is also a form of suffering.

————◆————

1426. A winding relationship can take one places.

————◆————

1427. Life is full of flux; the doctrine of karma tells us that a lot of it is reflux.

————◆————

1428. The world can be a very complex place—one discovers this when one tries to lead a simple life in it.

————◆————

1429. It is the filament of hope which keeps the bulb of life aglow.

————◆————

1430. If the roster of achievements is long, one may be sure that the litany of disappointments was equally long.

————◆————

1431. Should one mourn that stars have become vanishingly rare, when dawn is about to break?

---

1432. Why is it that what is emotionally magnetic is never far from becoming tragic?

---

1433. Some of the ads these days are so candid as to induce voyeuristic guilt.

---

1434. Sometimes our judgments judge us.

---

1435. Our ambivalence regarding whether God exists or not would be less agonizing if we realized that in either case our problems might still remain the same.

---

1436. Every achievement also leads to a predicament.

---

1437. Theological questions may not have theological answers.

---

1438. People may be irreplaceable and yet not indispensable.

---

1439. Not all farewells are final.

---

1440. Ambition needs courage.

1441. I am afraid we might be heading for a world in which everything is known but nothing is understood.

⟢⟐⟣

1442. Exaggerating a truth often compromises it.

⟢⟐⟣

1443. Why we hold a view should always be clearly distinguished from what the view is.

⟢⟐⟣

1444. That we are not part of the world we examine is our great illusion.

⟢⟐⟣

1445. Just as rising above ritual to the moral is a great advance, so is rising above moral to the spiritual.

⟢⟐⟣

1446. We may not acknowledge it as such, but all of us are waiting for an angel to enter our life. Waiting for the knight in shining armor, or the dream girl, are merely anemic versions of it.

⟢⟐⟣

1447. Unfortunately, what awes us often does not engage us, for if it did, then we would be on our road to becoming awesome.

⟢⟐⟣

1448. People resist change because they resist being changed.

⟢⟐⟣

1449. Facts can be created.

⟢⟐⟣

1450. Wrong theories can give right results.

⟢⟐⟣

1451.  Untruth may lie in the things not said.

———◆———

1452.  Is ornithology of any use to birds?

———◆———

1453.  One should never make the mistake of believing that what is generally held is also universally true.

———◆———

1454.  Each religious tradition must guard itself against sectarian capture.

———◆———

1455.  There is this curious ability of believers to put their beliefs behind them, without ceasing to believe in them.

———◆———

1456.  If, with Marx, society or economy is a way of interpreting religion, with Hinduism, religion is a way of interpreting society.

———◆———

1457.  The interesting thing is that good and bad parallel each other, and are, at the same time, the antithesis of each other.

———◆———

1458.  Through the alchemy of the passage of time, what is peripheral to a tradition at one point can become central to it at another.

———◆———

1459.  We extend as far as our fame, and shrink as much as our infamy.

———◆———

1460.  That one distinguishes between things does not mean that one discriminates among them.

———◆———

1461. People say: Follow your passion, and money will follow; unfortunately it often only follows in small amounts.

---

1462. Philosophy is universal and human beings are also found everywhere, yet somehow these two universalisms don't always coincide.

---

1463. Truth may be truth, and yet inadequate.

---

1464. In a scripture, a deeper meaning always awaits us.

---

1465. Religion uses reason, and yet may not be rational.

---

1466. When a person is free from personal desires, one becomes a part of the landscape.

---

1467. What were we like before Adam was born?

---

1468. What is the most exciting thing that could happen to us?

---

1469. I am all for gender equality, but I feel that female circumcision should not be equated with male circumcision.

---

1470. Primal religions consider themselves primal because they are closer to the beginning ontologically; historians consider them primal because they come first chronologically.

---

1471. Which of these is a greater achievement: to commit a crime which has no victim, or to pose as a victim when no crime has been committed?

———◆———

1472. Speak to me but never speak for me.

———◆———

1473. It is better to be in the same building, if we are not on the same floor.

———◆———

1474. It is not enough to think about the truth, it also needs to be told.

———◆———

1475. Is one morally justified to lie in answer to a question which should never have been asked?

———◆———

1476. A dog cannot bark if it has either a bone in its mouth, or a muzzle on it.

———◆———

1477. Could sexual harassment be the shadow side of sexual enticement, or is it sui generis?

———◆———

1478. Is it not a tragedy when what was once an electrifying phrase turns into a cliché?

———◆———

1479. Misery may like company but company does not like misery.

———◆———

1480. These two do not bode well for a society; inferior persons in superior positions, and superior persons in inferior positions.

———◆———

1481.  Experience is born when expectations collide with reality.

1482.  I am looking for a celebrity whose fame exceeds his or her popularity.

1483.  Would we still be mortal if we were perfect?

1484.  We all have our dark side, but does that mean that we should be blackened?

1485.  You cannot knock at an open door.

1486.  The danger of branding any aspect of culture as either good or evil is that it prevents us from objectively understanding its inner compulsions.

1487.  You will never be able to embark on a journey if you are waiting for the other shoe to drop.

1488.  Even if easy generalization is not possible, it is best to avoid rash or dismissive generalizations.

1489.  History repeats itself, first as tragedy, then as farce, and then as historiography.

1490.  It is as much possible to cling to a lie as to truth.

1491. The fact that something has become invisible does not mean that it is gone.

———◆———

1492. The problem with bearing the weight of the world on our shoulders, like Atlas, is that we have been designed to bear our own.

———◆———

1493. It is an intriguing fact that impersonal beauty, like that of a sunset, excites us as much as personal beauty, as in a beautiful person.

———◆———

1494. Some illusions end so suddenly as to amount to a new realization.

———◆———

1495. We can forbid certain thoughts from forming but can we similarly prevent some emotions from surfacing?

———◆———

1496. A world comes to an end when a friendship ends.

———◆———

1497. The thoughts which make us most uncomfortable are the ones we need to probe most.

———◆———

1498. The past is a museum.

———◆———

1499. A person without a constituency can easily pretend to be a citizen of the world.

———◆———

1500. Idiosyncracies attract attention, but unfortunately divert our attention from the complexities of an issue.

———◆———

1501. Suffering can be punitive, it can be redemptive, but can it be creative?

———————

1502. Humor directed at others is charming, and when directed at oneself, disarming.

———————

1503. The level of candor between two people is a good index of their level of trust.

———————

1504. It is relatively rare to find a person who combines wide learning with narrow convictions.

———————

1505. The true test of those who clamor for war comes when it is time to enlist.

———————

1506. Extreme statements attract attention, but at the same time detract attention from the complexity of the issue.

———————

1507. Fear of provocation leads to anticipatory compliance.

———————

1508. Human beings are perennial candidates for romance.

———————

1509. Zeal has to be unflagging zeal; it is not zeal if it flags.

———————

1510. Any factual account of our life will have fictional elements in it, of which we are not aware.

———————

1511.  All history is historical fiction.

———◈———

1512.  When we reveal our secrets we paradoxically become vulnerable and unconquerable at the same time.

———◈———

1513.  Obituaries are eulogistic not because they want to suppress less impressive facts, but because they carry the Roman saying: "Speak no ill of the dead," to the next level.

———◈———

1514.  Hamlet is tragic, but it is even more tragic to be a Hamlet without being a prince.

———◈———

1515.  A landscape which has become familiar is no longer a landscape.

———◈———

1516.  Fighting enemies one is ignorant of is no better than shadow-boxing in the dark.

———◈———

1517.  It is through its escape hatches that legality subverts morality.

———◈———

1518.  When do coincidences cease to be a coincidence and form a pattern; when does a pattern cease to be a pattern and become a law?

———◈———

1519.  An incredible experience may leave no evidence of the encounter.

———◈———

1520.  History is only as true as undisclosed evidence.

———◈———

1521. When there is giggle room, there is always wiggle room.

---

1522. The willingness to give the benefit of the doubt to someone may be described as a stance of sympathetic neutrality.

---

1523. I guess one cannot really complain about life so long as the challenges it poses are troubling but not overpowering.

---

1524. To be guilty of the appearance of impropriety is sometimes a greater crime in the modern world prone to publicity, than the impropriety itself.

---

1525. The reflected intimacy of devout proximity can never be a substitute for authentic intimacy.

---

1526. It is a revealing exercise to compare the wounds we have inflicted on ourselves with those we have inflicted, knowingly or unknowingly, on others.

---

1527. Can we other ourselves?

---

1528. The moment a man from the East enters the Western world, he feels overwhelmed by the prurient invasion of his vision by offensive ads, until one gets used to it. Do women from the West feel the same way?

---

1529. When the aging millionaire says at the end of *Some Like It Hot*, on discovering his fiancé is a man: "Nobody's perfect," he was displaying the outer limits of Hindu tolerance.

1530. The person who offered a piece of his chewing gum to the visitor, who kept looking at him, was probably carrying hospitality a bit too far.

1531. When the West boasts of introducing democracy to a Third World country, we get a glimpse of the superiority complex which comes from the belief that one has no superiority complex.

1532. It is the loose ends that unspool the finest fabric.

1533. One may shut the door on a proposal but should keep the window of opportunity always open.

1534. The celebrity trivia, which the media is so fond of sharing, has one redeeming feature—it reminds us that they are just us magnified.

1535. Ah! That magic moment when the irrelevant detail suddenly becomes relevant.

1536. Its proponents should note that a strident monotheism begins to look more and more like a supercilious frenzy.

1537. Will Wokism also, in due course, fall victim to revolution fatigue?

1538.  It is possible to be truthful and dishonest at the same time.

—————

1539.  Each nation has its own burden to bear, and it is not always the white man's burden.

—————

1540.  Can one insist on an etymological interpretation that renders the culture's history meaningless?

—————

1541.  Catharsis has its advantages, especially if it leads to renewal.

—————

1542.  We sometimes lie to avoid embarrassment, but in doing so we sometimes embarrass ourselves in our own eyes.

—————

1543.  There is a deep instinct in us to test the limits of a system, but it is as dangerous as it is deep.

—————

1544.  History is a constant struggle between our power to shape events and their power to shape us.

—————

1545.  Life is a strange spectacle—a bit out of focus but enabling us to see enough of it to tantalize.

—————

1546.  Reforming a living tradition is a little like trying to maneuver an object in space—how to manipulate it without causing it to spin needlessly.

—————

1547. Most of the apologies being routinely delivered now are really quite unapologetic.

———⟫◦⟪———

1548. The fact that the Kama Sutra contains the description of many positions, which defy anatomical possibilities, should alert us to the fact that part of our erotic life is also lived in the imagination.

———⟫◦⟪———

1549. The spurious intimacy of social media could be overlooked but for the fact that it is also injurious.

———⟫◦⟪———

1550. If your life changes, so does mine.

———⟫◦⟪———

1551. Somehow we feel that we should be given some moral credit for any reluctance we may bring to sinning, but I do not think it counts for much in God's court.

———⟫◦⟪———

1552. Sometimes all it takes for something to become an issue is for it to be articulated.

———⟫◦⟪———

1553. Even the display of humor by one who we thought did not possess it, tends to be taken as a serious matter.

———⟫◦⟪———

1554. Just as the letters of some housewives put the most crucial item in a postscript, the essence of what a scholar is trying to say is sometimes found in a footnote.

———⟫◦⟪———

1555. What if the spectator suddenly discovered that he or she were part of the drama?

———⟫◦⟪———

1556. A tradition is more than the sum total of all previous expressions of it.

———◆———

1557. Asian religions do not tend to guard their jurisdictions as zealously as Western religions do.

———◆———

1558. When one comes upon a car wreck as one is driving, one is confronted with a choice between being single-minded and being noble-minded.

———◆———

1559. The fact that truth may be relative cannot be taken to mean that it is non-existent.

———◆———

1560. There are degrees even in shyness; the shrinking violet belongs to a different class than the wall-flower.

———◆———

1561. To fast by day and dine by night may not be too bad a blending of asceticism and hedonism.

———◆———

1562. Writing an autobiography is like showing a tattoo in a private place. One wants to show the tattoo but not too much around it.

———◆———

1563. Just as exaggerations might increase the impact of facts, euphemisms diminish it.

———◆———

1564. A gentleman scholar never attributes motives to one's critics which are different from one's own.

———◆———

1565. The problem is that sometimes the oppressor and the oppressed fall into a rhythm, which may be as bewitching as it may be deadly.

1566. If one can see an archetype in a stereotype, one can escape out of the ordinary into the universal.

1567. If one must put up walls, then it might be wise to have a few windows in it.

1568. A shocking detail can destroy a whole web of lies.

1569. It will not help to say that one's interest was merely voyeuristic, and not prurient, if one is caught looking.

1570. More than one view can stake a claim to not only correctness but also to political correctness, depending on how power is distributed. This is what makes it so hard to adjudicate matters in modern times.

1571. The historian is sometimes a musician, in whose hands evidence can become like an accordion, to be expanded or compressed to one's sense of rhythm.

1572. Every secretary, to some extent, becomes, over time, an accomplice of the boss.

1573. We are less likely to commit a misstep when we are under fire, than when we are over-confident.

———◆———

1574. Those who pose too often as victims end up inviting victim-hood.

———◆———

1575. To be psychoanalyzed is, to a certain extent, indistinguishable from being vivisected.

———◆———

1576. What some might consider trivial, others could consider telling.

———◆———

1577. If verbal language says one thing, and body language another, then trust the body language.

———◆———

1578. One can, of course, be served old wine in new bottles, but one can also be served new wine in old bottles.

———◆———

1579. Virtue signaling is an oxymoron.

———◆———

1580. The fact that we did something bad reluctantly will not get us any brownie points with Karma.

———◆———

1581. Karma asks us to focus on our actions, but what about the actions of others?

———◆———

1582. It does not take much to convert an assistant into an accomplice.

———◆———

1583. That we do not really do anything as an independent agent is the ultimate alibi.

———◆———

1584. It is sometimes claimed that truth is what remains true in the past, present, and future. This statement overlooks the fact that there could be a past, a present, and a future parsing of the truth.

———◆———

1585. Any account of our life is going to be a somewhat fictionalized account of our lives.

———◆———

1586. An unintended overtone is very hard to correct, because it is often taken as representing a psychological truth.

———◆———

1587. It is a coveted moment in an intellectual's life when a selected bill of particulars begins to yield a general pattern.

———◆———

1588. What is politically correct may not always be politically sound.

———◆———

1589. A society obsessed with rights will inevitably become an exploiting society, just as a society obsessed with duties will become an exploited society.

———◆———

1590. Ideologues wanting to perpetuate their legacy may be better off doing it through a disciple rather than a son.

———◆———

1591. Nothing is more misleading than a true but incomplete statement.

———◆———

1592. When trapped in legalities, it is best for both sides to try to resolve the issue in a non-legal context.

1593. Sometimes morality just boils down to etiquette.

1594. People complain of selective moral outrage, but would it be possible to psychologically survive a state of comprehensive moral outrage, because virtually every situation can be converted into a moral dilemma.

1595. If two people fight over an umbrella in the rain, both get wet.

1596. The pyramids are a huge reference point of ancient Egyptian civilization.

1597. Confidence without ability is a dangerous combination.

1598. I wonder if those feminists, who run down Christianity realize that monogamy is Christianity's gift to the world.

1599. To fear death is to fear life.

1600. Have you ever experienced that moment of revelation when an accumulated mass of detail loses its randomness.

1601. Oral cultures are based on memory, literary cultures on history, or a library.

1602. What's the point if you walk the talk, but don't talk the walk?

<center>⟫•⟪</center>

1603. The truth is often obvious to one who has no agenda.

<center>⟫•⟪</center>

1604. I often discover, to my horror, that I have been totally wrong.

<center>⟫•⟪</center>

1605. A virtue is not always a virtue.

<center>⟫•⟪</center>

1606. What is historical is not always logical, although historians try their best to prove that it was.

<center>⟫•⟪</center>

1607. Things which look different may be the same, and things which look the same may be different.

<center>⟫•⟪</center>

1608. Is it possible to be comprehensive, without, at the same time, being indiscriminate?

<center>⟫•⟪</center>

1609. Logic has power, but power has its own logic.

<center>⟫•⟪</center>

1610. Just because someone has treated one badly does not necessarily mean that the person is bad. He or she has friends too.

<center>⟫•⟪</center>

1611. Fundamentalism means that the divine spark can become a ball of fire.

<center>⟫•⟪</center>

1612. If creation is God having fun, Hinduism is religion having fun.

<center>⟫•⟪</center>

1613. Sometimes one needs to change the world before the world changes one.

———◦———

1614. You may not be interested in the world, but the world may be interested in you.

———◦———

1615. Who is the best person in your life?

———◦———

1616. One may suffer, but there is no point in becoming a victim of your suffering.

———◦———

1617. Can eccentric insight be a substitute for deft analysis?

———◦———

1618. The best path is that which enables you to become yourself.

———◦———

1619. Are you selfish? Nobody thinks so. Yet everyone thinks that the world is selfish!

———◦———

1620. Partisanship puts scholarship in suspended animation.

———◦———

1621. A necessity need not be a goal.

———◦———

1622. One must always avoid the temptation to want to fight the fight on hand, rather than the one we want to fight.

———◦———

1623. They say the only immutable law is Murphy's, but sometimes life does seem perfect.

1624. To enumerate is one thing, to evaluate another.

1625. Nothing is more draining than a battle with oneself.

1626. Even a string of lies is strung on its claim to truth.

1627. The power of truth becomes apparent to us when we know something to be a lie but others don't.

1628. Is there a rational breaking point also, just as there is an emotional breaking point?

1629. Those ailments are the worse which are corrosive without being explosive.

1630. It is easy to lose one's moral compass when the ship is about to sink.

1631. Fiction is important—we may have to distort reality at times to survive.

1632. There is an ambiguous realm between the legal and the moral which tests out honesty.

1633. Savagery as a response to savagery is still reprehensible even if more understandable.

1634. The fact that we still derive a superstitious thrill when we face a development which makes us yell—Karma is a bitch!—shows us how far we have yet to travel beyond our basic instincts.

1635. Not to hurt someone more than necessary is also an expression of love.

1636. Can you ask of one of the two railway tracks which is more necessary?

1637. When one brings up an unpleasant fact, one may be wanting to balance the account, rather than wanting to besmirch others.

1638. Every sinner has a future because every saint has a past.

1639. The game is not over until the last ball has been played.

1640. What we thought was impersonal can turn out to be personal, and what we thought was personal can turn out to be impersonal.

1641. Both doubt and faith possess the power to transform our lives.

1642. Sometimes the disease creates the cure, and sometimes the cure creates the disease.

1643. The paralysis of analysis requires the refreshing treatment of decisive action.

———◦———

1644. With hierarchy comes deference; with equality, vivacity.

———◦———

1645. Myths can change history, just as history can change myths.

———◦———

1646. The first principle of writing is not to chase the reader away.

———◦———

1647. It is the concept of justice or law, which creates the phenomenon of crime.

———◦———

1648. Hinduism uses myths to bring people together; the West uses history to divide them.

———◦———

1649. We are reborn because nobody wants to die.

———◦———

1650. Don't die before your death.

———◦———

1651. Truth persists in the face of error; error disappears in the face of truth.

———◦———

1652. It is good to want to do good to people but before we do so, we need to ask ourselves—Do we have the necessary competence and skills to do so? One needs to be a doctor before one can help a patient.

———◦———

1653. When you identify with the drop, you remain a drop in the ocean; when you identify with the ocean, you become an ocean in a drop.

1654. The great enemy of knowledge is false knowledge.

1655. Not only is asking half of knowledge, it is also the half of getting anything.

1656. There is no full stop in history. There are a lot of exclamations and question marks, and even a few semi-colons, but there is no full stop in the punctuation of history.

1657. Do the dead talk about life, the way we talk about death?

1658. The idea of having a body permanently is different from that of having a permanent body.

1659. The slave whips himself instead of the master.

1660. What is normal for one may be abnormal for another, and sub-normal for someone else.

1661. Not all gifts come gift-wrapped.

1662. There is a difference between ignorance, false knowledge and useless knowledge.

1663. Why ask: why me?—when we don't know what others are going through?

1664. The forest may be shrinking while we are busy counting the trees.

1665. Being detached does not mean being heartless.

1666. Life—ever aging, never old?

1667. If justice is not delivered in time, it starts looking more and more like revenge.

1668. After such ignorance—what forgiveness?

1669. From a Marxist perspective, friction produces fire and fire produces light.

1670. Death is a part of life, but is life a part of death?

1671. When the bulb goes out it is not electricity which goes out, it is the bulb which has gone out. Electricity is not local, its manifestation is.

1672. Would you pluck a flower, or water it?

1673. Life spares none. Neither does death.

1674.  We fear like mortals, while we dream like immortals.

—◆—

1675.  When we seek perfection we must remember that we seek it in an imperfect world. At the same time, we should not forget that this cannot be a reason for not seeking it.

—◆—

1676.  When I say "I am forgetting again," am I having deja vu all over again?

—◆—

1677.  In order to be manipulated, the victim must not know that.

—◆—

1678.  We can make a mistake even when we are doing good to others, but we do not suffer the consequence. Is this the less lofty reason why we try to help others?

—◆—

1679.  I revise Wittgenstein as follows: The limits of my languages are the limits of my knowledge.

—◆—

1680.  Groups are easier to win over politically when they become a class.

—◆—

1681.  If you want the future to be different from the present, study the past.

—◆—

1682.  On the road to ultimate success, temporary failures may be as important as temporary successes.

—◆—

1683. A person's views may be questioned, but a person's right to his or her views may never be questioned, because we hold our views by the same right.

1684. To live life, without knowing the meaning of life, is a little like receiving a present without knowing what it is.

1685. Could it be that the world is created for fun, like a game? One does sometimes get hurt playing one.

1686. A plan is something your mind sees, but a vision is something your heart sees.

1687. One can be superior without being perfect.

1688. In a rapidly changing world, the children pity the elders and the elders pity the children.

1689. One looks at the fire; another at the ashes.

1690. Once in a while, we should try to think without words.

1691. As long as a person has desires, the desires have him, or her.

1692. With freedom comes vulnerability.

1693. Don't ruin your case by making it lop-sided or one-sided.

---

1694. Ideological fervor does not render moral issues irrelevant.

---

1695. Moral fervor cannot always answer metaphysical questions.

---

1696. The ups and downs of life contribute equally toward advancing us to our goals. It is the revolving wheel which moves the chariot to its destination.

---

1697. If necessity is the mother of invention, resources are its father.

---

1698. Is it possible to be both highly civilized but poorly cultured?

---

1699. A friend is one whom you would like to meet every time you could.

---

1700. Some people like to say sorry after killing you.

---

1701. A good indication of your success is the caliber of your enemies.

---

1702. Can truth also have many variations, just as a lie could have many?

---

1703. There is a lot of difference between what is said and what is heard.

---

1704. Just because some people believe in absurdities does not mean that they commit atrocities.

1705. Most people *coddiwomple* through life. The word means to travel purposefully toward an as-yet-unknown destination.

1706. Being traditional may not require being conventional.

1707. Our future is often a thing of the past.

1708. If you don't change your view after the facts or evidence on which it was based has changed, then you are either braindead or brainwashed.

1709. Everything seems fine until one starts going deep into it.

1710. Virtue may protect one from sin, but it does not protect one from crime.

1711. Seek at least excellence, if not perfection.

1712. Some of our plans succeed. Some of our plans fail. The charm of life consists in discovering which of them succeeded and which failed.

1713. You can tell a truth by lying, and lie by telling a truth.

1714.   Things don't get done because people prefer conversation to action.

———◆———

1715.   We do not get what we want from life, because we want mutually contradictory things from it.

———◆———

1716.   The thought belongs to the person who says it best, and the idea belongs to the person who implements it best.

———◆———

1717.   Choose your friends carefully, and your enemies even more so.

———◆———

1718.   Every culture in the world has a word for infidelity, yet marriage is one of the most enduring institutions ever devised by human beings.

———◆———

1719.   Science keeps telling people how, and human beings keep asking why?

———◆———

1720.   Those who fall in love with people of size can explain this in Newtonian terms: the greater the mass, the greater the force of attraction.

———◆———

1721.   Every religion, at any point in time, represents only a partial realization of its full potential.

———◆———

1722.   Any book worth reading is a book worth having.

———◆———

1723. Change changes you, but you can also change the change.

1724. People resist change because they resist being changed.

1725. The more calm you are, the less confused will the world appear.

1726. We cannot be truly ourselves unless those around us are not truly themselves.

1727. Life does not so much change people as it unmasks them.

1728. Things happen through us but it seems as if they are happening to us.

1729. If you can't make somebody understand it, you don't understand it.

1730. Everything is beautiful, it all depends on the angle from which you are looking at it.

1731. Doubts make truth appear fragile.

1732. If only we knew where inspiration comes from.

1733. At twenty you seek the opposite sex; at forty, the opposite sex seeks you.

1734.  Two people may stand at the same place but might be looking in very different directions.

———◆———

1735.  We may see perfect things imperfectly, and imperfect things perfectly.

———◆———

1736.  Many people looking for heaven end up in hell.

———◆———

1737.  We are neither as good or bad as we imagine.

———◆———

1738.  It is the fact that we are all different, which makes meeting another person such an adventure.

———◆———

1739.  To be born is to be the new kid on the block forever.

———◆———

1740.  We may never be able to know another person fully, but that need not mean that we cannot know them at all.

———◆———

1741.  If you clutch someone too close to your chest, you may miss out on meeting the next person.

———◆———

1742.  It is a strange fact that we often most believe what we most doubt.

———◆———

1743.  Make sure you don't miss out on the pattern while seeking precision.

———◆———

1744. We don't have to love the world to love the people in it.

1745. A river is flowing toward the sea even when it does not seem to be doing so.

1746. Life may be like prose but finding love in it is surely poetry.

1747. God may forgive us, but can we forgive ourselves?

1748. Inspiration is hard to sustain. If prolonged, it fades away, and if it fades away, it cannot be prolonged.

1749. The tragedy, or comedy, of love is that the two parties rarely love each other equally. Often one loves more, or less, than the other.

1750. A faithful man makes a woman feel secure but the romantic man wins her.

1751. The bird may soar far away in the sky, but it finally returns to the branch.

1752. We love God for what God is; God loves us in spite of what we are.

1753. Silence is the farthest difference between two people.

1754. This is the paradox of seeing: the more closely we see something, the less we see other things.

1755. If you want to know how much you love a person, look at how far you will be able to forgive that person.

1756. What you see when you look *at* a height is very different from what you see when you look *from* it.

1757. We may not have it all together, but together we have it all.

1758. Karma says that we create our joys and sorrows before we experience them.

1759. We are sometimes afraid to share our deepest dreams even with ourselves.

1760. Love entails suffering.

1761. We suffer with what we identify, but we need not identify with what we suffer.

1762. The mind can forgive the heart but the heart will never forgive the mind.

1763. Only one koan matters—I?

1764. Even after you have lost everything, you still have yourself.

1765. It is in our moments of doubt that faith is shaped.

1766. We have found someone, when we are ready to lose ourselves in that person.

1767. What will happen to us cannot be arranged with precision but we can be precise about how it all has to be faced—calmly.

1768. One can believe in God the way one believes in space—not because one sees it but because, because of it, one sees everything.

1769. Abstention is the greatest aphrodisiac.

1770. It is always a battle between what you want to control and what you will let control you.

1771. A candle is not any worse off by lighting another candle, nor we by helping others.

1772. Sometimes it is enough to know that you don't know enough.

1773. It is so heart-breaking to break with someone whom one once loved, and has now ceased to. It has whiff of tragedy in it.

1774.  Prayer may not affect the object of worship but it surely affects us.

—————

1775.  Sometimes things have to be changed to maintain the status quo.

—————

1776.  The more things seem to be the same, the more they change.

—————

1777.  The mind feels it as optimism, the heart feels it as hope.

—————

1778.  What if all of us are the same person playing different roles?

—————

1779.  It is magnificence when we like it and opulence when we don't.

—————

1780.  Have you ever experienced intransitive love?

—————

1781.  You have found the person you can live with, when you find the person you cannot live without.

—————

1782.  One should speak on these two occasions: when one can improve upon the silence, and when one can improve the occasion by silencing someone.

—————

1783.  We may still be on the path when we are down in the dumps.

—————

1784.  To see the tenacity of memory, try forgetting something.

—————

1785. I want to know who is your role model—that will tell me more about you than the model.

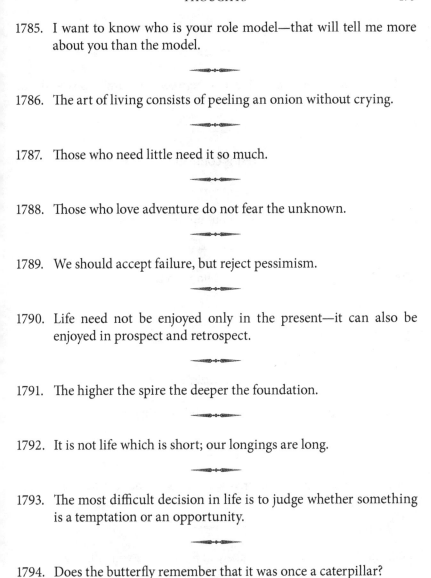

1786. The art of living consists of peeling an onion without crying.

1787. Those who need little need it so much.

1788. Those who love adventure do not fear the unknown.

1789. We should accept failure, but reject pessimism.

1790. Life need not be enjoyed only in the present—it can also be enjoyed in prospect and retrospect.

1791. The higher the spire the deeper the foundation.

1792. It is not life which is short; our longings are long.

1793. The most difficult decision in life is to judge whether something is a temptation or an opportunity.

1794. Does the butterfly remember that it was once a caterpillar?

1795. The sun, which is itself a star, makes all others disappear when it shines.

1796. The book we love most is the book we wish we had written.

---

1797. The basic tension of life lies between our ambitions and our limitations.

---

1798. Birth is the text—the rest is commentary.

---

1799. We can get rid of the weed but not of the thorn.

---

1800. Both the flower and the weed flourish together.

---

1801. We should be careful that we don't do away with the dress as we do away with the finery.

---

1802. We all live under the same sky but it rains in different places at different times.

---

1803. The clay of life is watered with tears to make it supple, as it is being recast.

---

1804. Resistance can either make you fly or make you fall.

---

1805. Those who want to be everything to everyone may find it hard to be something to someone.

---

1806. For the children, the parents are the whole world, and then they grow up. Then the parents become just two persons in their world.

———◆———

1807. Happiness is the consciousness of love.

———◆———

1808. Watch what you recoil from—it may represent your greatest fear.

———◆———

1809. Don't just be a Christian—be Christ.

———◆———

1810. On the road to liberation, one might discover that there is no one to liberate.

———◆———

1811. Don't ask God for things to enjoy in life. God has given us life.

———◆———

1812. How will other things get better if we want some things to remain the same.

———◆———

1813. Do we make the journey, or does the journey make us?

———◆———

1814. Do we catch the cold, or does the cold catch us?

———◆———

1815. Do we go to sleep, or does sleep come to us?

———◆———

1816. Anything can happen at any time—but doesn't.

———◆———

1817.   We control what we are conscious of, but what if the unconscious part of us controls what we are conscious of.

1818.   It is even more important for people to understand where you stand, than what you stand for.

1819.   May my eloquence become more silent.

1820.   If a message has been conveyed succinctly, to add would be to subtract; if it has been conveyed verbosely, to subtract would be to add.

1821.   It requires some imagination to recognize that the flower is in the seed.

1822.   The wind can carry away the seed, but when it grows into a tree it can block that wind.

1823.   The physical heart is as tough as the emotional heart is tender.

1824.   Sometimes it takes time, both to understand a truth and to make others understand it.

1825.   Do the scraps of our life hide a map?

1826.   Isn't it strange that sometimes the person who can guide us to our goal may be standing far away from the goal?

1827. What we are really looking for is unconditional love. But can we resist the temptation to exploit it when we get it?

—————

1828. The sky is blue irrespective of the color of the eye looking at it.

—————

1829. Nothing hurts, or everything hurts.

—————

1830. What are weaknesses in men are often considered strengths in women and what are strengths in women are often considered weaknesses in men.

—————

1831. The right woman makes one a better man, and the right man makes one a better woman.

—————

1832. There is all the difference in the world between liking someone because you need them, and needing someone because you like them.

—————

1833. One should not be too lost in love to last in love.

—————

1834. Socialism is based on the principle that when together we can have, what we have not had so long together.

—————

1835. We may have the right to do something and yet it may not be the right thing to do.

—————

1836. The art of living, in good measure, consists in stumbling without crumbling.

———◆———

1837. The tension between whether you go or I go is caused by the ego.

———◆———

1838. We usually become wise at the end, when we should have been so at the very beginning.

———◆———

1839. Love makes a man vulnerable and a woman invincible.

———◆———

1840. It is easier to overcome fear than nervousness.

———◆———

1841. When the sun reaches its zenith, it casts no shadow.

———◆———

1842. We think of eternity as being always present, but the present is also always present.

———◆———

1843. Those who have been hurt in love, may love to hurt.

———◆———

1844. It is a saving grace of life that imperfect people can have perfect relationships.

———◆———

1845. Our mythical conversations with ourselves seem to be a persistent effort to negotiate the twin claims of self-acceptance and self-criticism.

———◆———

1846. The search for perfection, elusive though it might be, enables us to achieve more than we would otherwise.

1847. We are first estranged from ourselves before we become estranged from others.

1848. Don't seek a sign from God, seek the design of God.

1849. We ever know that we will never know what lies in store for us.

1850. Craving and despair go hand in hand.

1851. We will not feel torn between joy and sorrow if we realized that they constitute a pair.

1852. It is hard to tie the knot if you are stringing somebody along.

1853. Forgiveness is a beautiful thing but it might invite aggression if one does not possess the capacity to retaliate.

1854. We may need most what we deserve least.

1855. Wisdom ceases to be wisdom when it comes after the event.

1856. Astuteness ceases to be a virtue when it becomes cleverness.

1857. When a perfect alignment ceases to be so, one must ask: who moved?

1858. Is nothing inevitable until it happens, or is everything inevitable when it happens?

1859. The deeper you are in the water, the farther you are from the shore.

1860. Waking up from a dream is quite different from waking up in a dream.

1861. With some people we look and then listen, with others, we listen and then look.

1862. There is no understanding without some misunderstanding, and no misunderstanding without some understanding.

1863. Would it not make a lot of difference to how we live, if instead of fearing death we welcomed it?

1864. The same wind which rustles in the forest spreads fragrance in the garden.

1865. What angers us tells us what we care about most.

1866. Think before you have to.

1867. We are punished neither for our sins nor by our sins, we are punished for identifying with our sins.

1868. The opposite of knowledge is not ignorance but false knowledge.

1869. When we offer love and don't receive it, we learn something; when we receive love and don't offer it, the other party learns something.

1870. When we cry at a death we perhaps grieve as much over our mortality as theirs.

1871. Everything is a gift, if we expect nothing.

1872. The pain of losing a privilege might exceed the pain of gaining it.

1873. Sages are like children because they accept whatever happens.

1874. From the fact that what is learned becomes natural in due course, can we deduce that what comes naturally to us was also once learned.

1875. If you mind something which does not matter could well indicate that there are matters you won't mind.

1876. The value of a thing does not depend on whether it is hard or easy to do but on its appropriateness.

1877. The middle of nowhere is also somewhere.

—◦—

1878. Do we take a journey to a place, or does the journey take us to the place.

—◦—

1879. Talking about human beings in the abstract is very different from meeting a human being in person

—◦—

1880. Silently appreciating someone's virtues means nothing to the other person.

—◦—

1881. Adolescence liberates us from childhood, youth from adolescence, maturity from youth, old age from our mature years, and death from old age. Or one can say that each destroys the other. It is all a matter of attitude.

—◦—

1882. What displeases us reveals our preferences, but what annoys us our taste.

—◦—

1883. Some drown in deep waters; others get cleansed.

—◦—

1884. If we have it, we think little of it, but if we have little we think a lot of it.

—◦—

1885. We remember how we felt more deeply than what we thought.

—◦—

1886. We do those things best which we do without having reason to, the way a bird might break out into a song.

———◆———

1887. Separation precedes communication.

———◆———

1888. Mental separation precedes physical separation.

———◆———

1889. We may be born of two people but we learn from many.

———◆———

1890. There are no foolish questions, only foolish answers.

———◆———

1891. What intoxicates us also poisons us.

———◆———

1892. You have led a good life so long as you don't look down, when someone says your name.

———◆———

1893. Flowers can rot, and weeds can flower.

———◆———

1894. Are we prepared to accept that both weed and flower are expressing their own truth?

———◆———

1895. We reach our heights when we are with others; we plumb our depths when we are alone.

———◆———

1896. Meditation sweeps away the dust of daily life.

———◆———

1897. It is better to explain than to tell, better to illumine than to explain, and better to inspire than illumine.

1898. It takes a lot of knowledge to discover one's ignorance.

1899. There are three forms of communication; head to head, heart to heart, hand to hand. Then there is a fourth; soul to soul.

1900. If the sky falls, it would first hit the tallest.

1901. We can never catch our horizon, just as we cannot think the thinker.

1902. If one could heal everyone, one would be healed too.

1903. To heal others is to heal oneself.

1904. There is a danger in analyzing something too much. We may forget that petals belong to a rose.

1905. A man's heart is in the head, a woman's head is in the heart.

1906. We render ourselves most vulnerable when we express our love for someone.

1907. For the narcissist, their heart is the world; for the altruist, the world is their heart.

—◆—

1908. You don't go to heaven, heaven comes to you.

—◆—

1909. The greatest witness of your actions is you.

—◆—

1910. It is good to have electricity surging between people as it were. The only problem is that high voltage can also electrocute.

—◆—

1911. Those who need each other to begin with may end up cherishing each other.

—◆—

1912. Walls may become doors if you kick them hard enough.

—◆—

1913. Hard work makes us lucky.

—◆—

1914. We judge others by our standards, but by what standards do we judge ourselves?

—◆—

1915. Truth has no color. White, black, and gray are shades we attribute to it.

—◆—

1916. How something was achieved could be a way of morally assessing that achievement, short of being blinded by it.

—◆—

1917. The thorn is there to keep us from plucking the rose.

1918. A prayer may or may not bring us closer to God, but it surely brings us closer to ourselves.

1919. It is good to have someone to bid good-bye.

1920. Is it true that even objects attract each other?

1921. It is unfortunately not the case that when the master ceases to be a master, the slave ceases to be a slave.

1922. Everyone wants justice, yet few agree on what it is.

1923. In worrying about what might be, we forget what is happening right now.

1924. To flirt by not flirting is called Zen flirting.

1925. We try to love others the best way we know how, without knowing how they would best want to be loved.

1926. A conscientious person may be forgiven by others, but experiences great difficulty forgiving oneself; an arrogant person has little difficulty forgiving oneself when others have great difficulty forgiving him or her.

1927. There are things you will tell a friend but not write in your diary; there are things you will not tell a friend, but write them in your diary.

———◆———

1928. If we do not get what we love, we start loving what we get.

———◆———

1929. A knot becomes undone not by pulling at it but by working at it.

———◆———

1930. What is processed in our subconscious can still come out right. Pictures are developed in darkness, but their beauty is seen in light.

———◆———

1931. Philosophy means love of truth and for good reason. You do not always understand what you love.

———◆———

1932. Our most intimate dreams make us feel lonely.

———◆———

1933. Both love and anger cloud our vision, one pleasantly, the other unpleasantly.

———◆———

1934. It is the very height of oppression not to be able to say that one is oppressed.

———◆———

1935. Have you ever wished you knew what was the right thing to do? If not, one will never be able to understand the appeal Sharia law has for Muslims.

———◆———

1936. Why is it that, although we tell the person we love repeatedly "I love you," it is not considered repetition?

1937. Our lives are short poems, are they part of an epic?

1938. The past is never past and the future is already here.

1939. People say that one should not talk ill of the dead. But it is only after a person is dead that one can really assess the effect of the person's life.

1940. Caution means checking whether a toilet-paper dispenser has paper in it before settling down.

1941. Being good is not the only way of doing good.

1942. My goal is to be the nice guy who does not end up last.

1943. Forgiveness is revenge enough.

1944. Do people love God because unrequited love lasts forever?

1945. Convert fear into anger.

1946. Find your limits.

---

1947. Love may be the absence of judgment—but not of discrimination.

---

1948. Did God create temporality because he got bored with eternity?

---

1949. I gave up mathematics because I was tired of finding the value of my $X$ (ex).

---

1950. One is what one is. To think of oneself as great or small is equally false.

---

CPSIA information can be obtained
at www.ICGtesting.com
Printed in the USA
JSHW021625130123
36239JS00001B/3